Atkinson**Grimshaw**

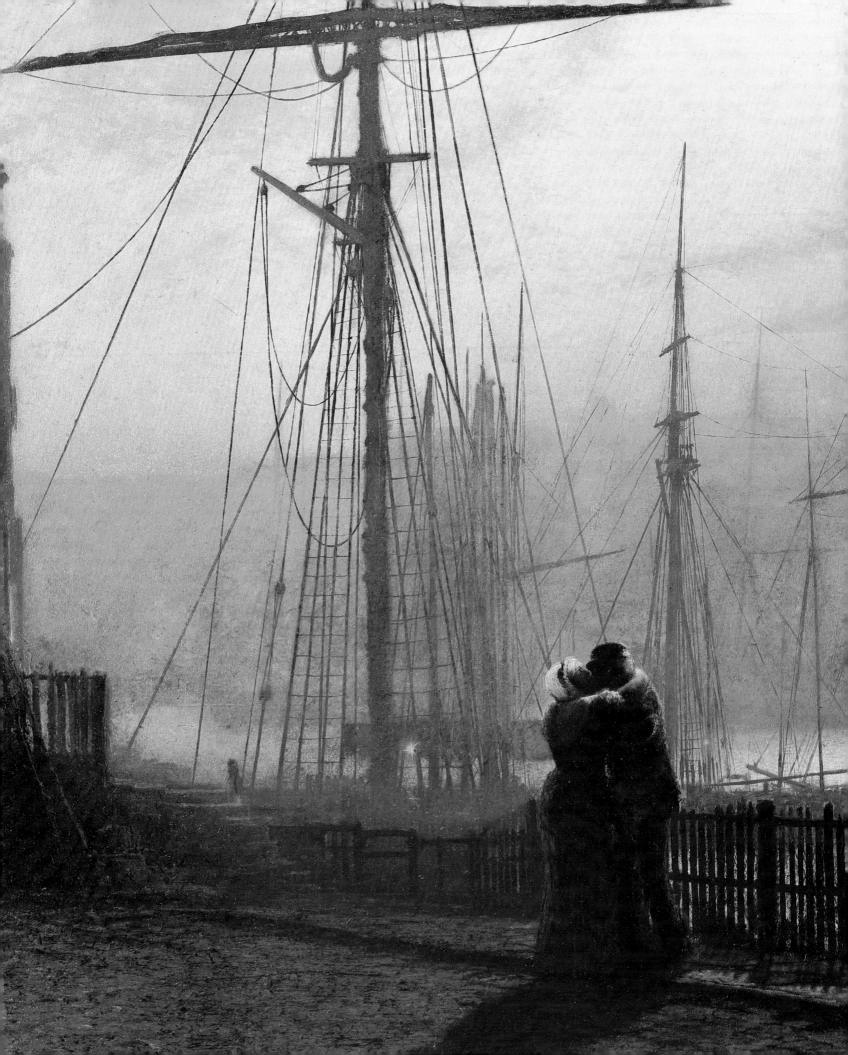

Atkinson **Grimshaw**

Alexander Robertson

For my father
and in memory of my mother

Phaidon Press Limited
Regent's Wharf
All Saints Street
London N1 9PA

First published 1988
Reprinted in paperback 1996
Reprinted 2000

ISBN 0 7148 3575 7

A CIP catalogue record for this book
is available from the British Library

Printed in Singapore

Front cover illustration:
Park Row, Leeds.
1882. Oil on canvas,
76.2 x 63.5 cm (30 x 25 in).
Leeds City Museums (Plate 74)

Back cover illustration:
Atkinson Grimshaw (Plate 2)

Title page: *Home Again*. *c*.1877–9.
Oil on board, 39.4 x 62.2 cm
(15½ x 24½ in).
London, Bury Street Gallery

CONTENTS

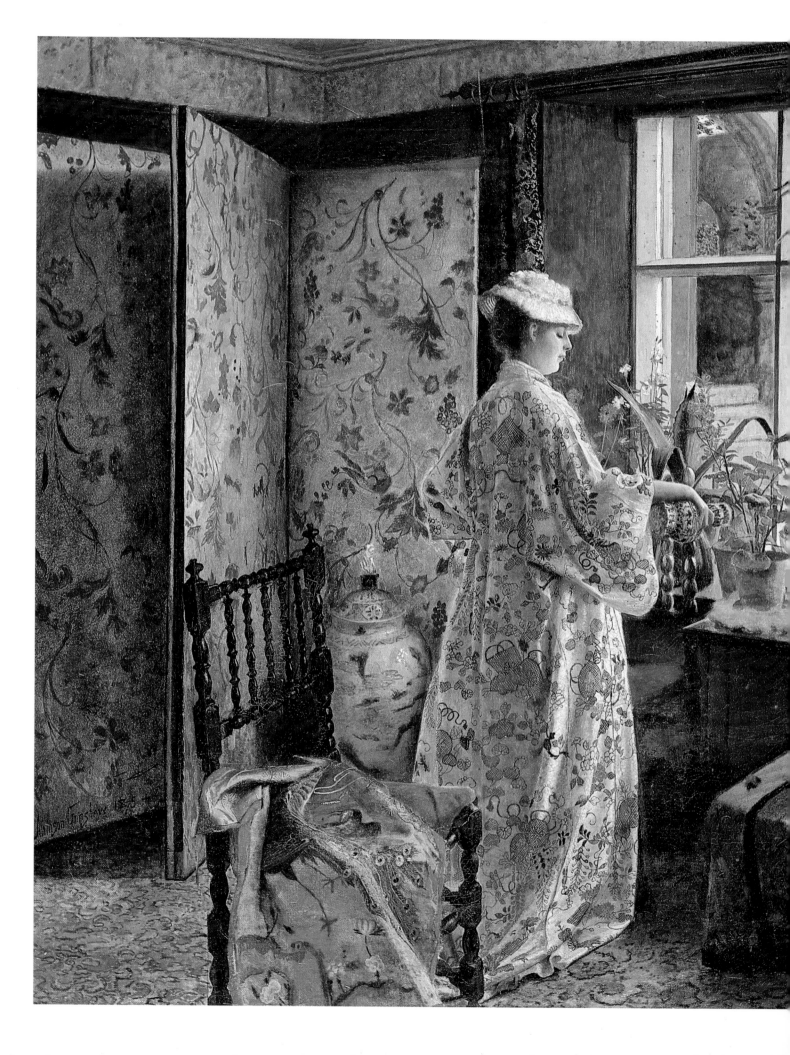

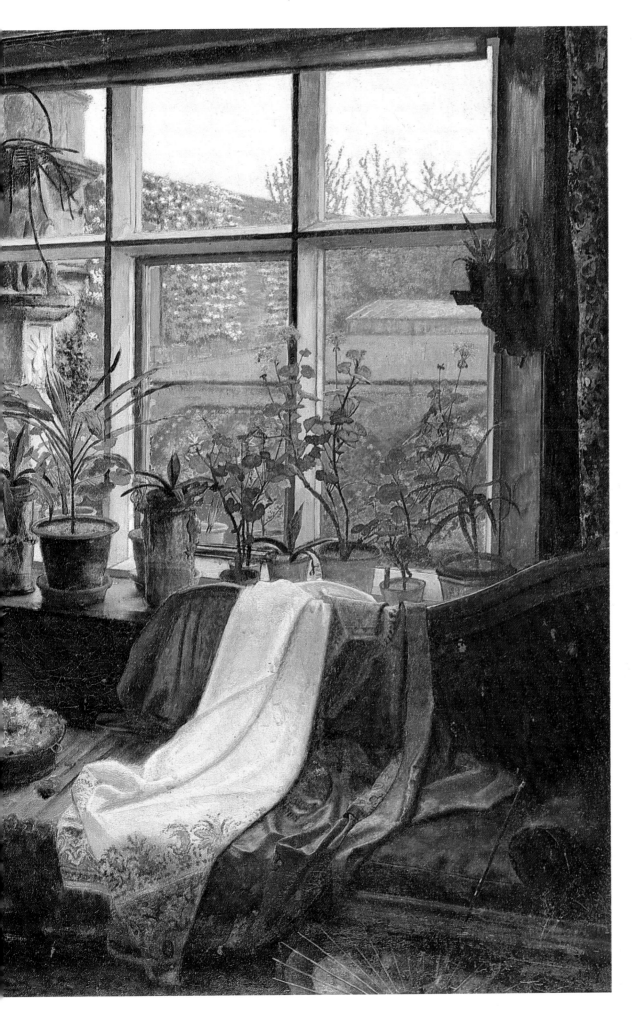

1. *Spring.* 1875. Oil on canvas, 61 × 91 cm (24 × 35⅞ in). Private collection

PREFACE

Most of our knowledge of John Atkinson Grimshaw's early life comes from the researches of the artist's grandson, Mr Guy Ragland Phillips, whose mother, Elaine Grimshaw, was able to pass on some important details relating to her father. Mr Phillips's researches have been published over a number of years in magazine articles and exhibition catalogues. Apart from such valuable clues, we must rely on newspaper reviews and the paintings themselves for a discussion of Grimshaw's life.

In spite of early local success in Leeds and the north of England, as well as a recognized London career from the 1870s, contemporary accounts of Grimshaw's career are virtually non-existent. Even his artistic and theatrical acquaintanceship with James McNeill Whistler, Ellen Terry, J. L. Toole, George du Maurier and Wilson Barrett did not result in any biographical mention in memoirs, diaries or biographies. The almost complete lack of contemporary references leaves the present-day researcher with only the barest outline information. The few letters now extant deal with family news and a visit to Redhill to see the artist John Linnell. Grimshaw thus remains as shadowy and enigmatic as his 'moonlights'.

In preparing this text on John Atkinson Grimshaw, I should like to acknowledge the contribution made by Dr David Bromfield to the 1979 Leeds exhibition. His perceptive new look at Grimshaw has done much to reassess his career and achievements. Collectors of Grimshaw paintings have given me a particularly warm welcome and I would especially like to thank Mr and Mrs Ian Appleby, Mr Stanley Butterworth, Mr Alan Class, Mr Harry Patterson and Mr George Watson for their kind co-operation. I also owe a special thank you to colleagues and friends in the art world who have helped in the preparation of this book: Lady Abdy of the Bury Street Gallery; Mrs Maria Baer; Miranda North-Lewis and Jovan Nicholson of Christie's; Owen Edgar; Peyton Skipwith of the Fine Art Society; Anne Ross of the Richard Green Gallery; Jeremy Maas; Alice Munro-Faure and Simon Taylor of Sotheby's; and Christopher Wood, who have all been very generous with their time and with the loan of photographs.

My colleagues at Leeds deserve special thanks for their support and useful suggestions, notably Corinne Miller, and Michael Sheppard, the Leeds City Art Galleries picture restorer, who has been most helpful with information about Grimshaw's painting methods; and also Terry Friedman who has long urged me to write a book on Grimshaw. I have also been fortunate to have had the help of several volunteers who have researched the Leeds newspapers on my behalf: Hilary Brosh, Katie Coombs, Andrew Lynn and especially Susan Dales. As always the staff in the Local History department of Leeds City Libraries, Anne Heap and Michele Lefevre, have been generous with their time and assistance.

Finally I am grateful to the following who have made many helpful suggestions and have answered requests for information: Caroline Arscott, Mrs P. Barnes, Mrs Diane Bissatt, Peter Brears, Adrian Budge, Jane Farrington, Richard Green, Sue Parker, Leslie Parris, Mr E. R. Pearson and Miss R. Watson.

By no means least, I record here my thanks to my editor Ruth Maccormac, designer Isobel Gillan, picture researcher Denise Hardy and copy-editor Julian Ward, with whom it has been a pleasure to work.

Alexander Robertson, Leeds, January 1988

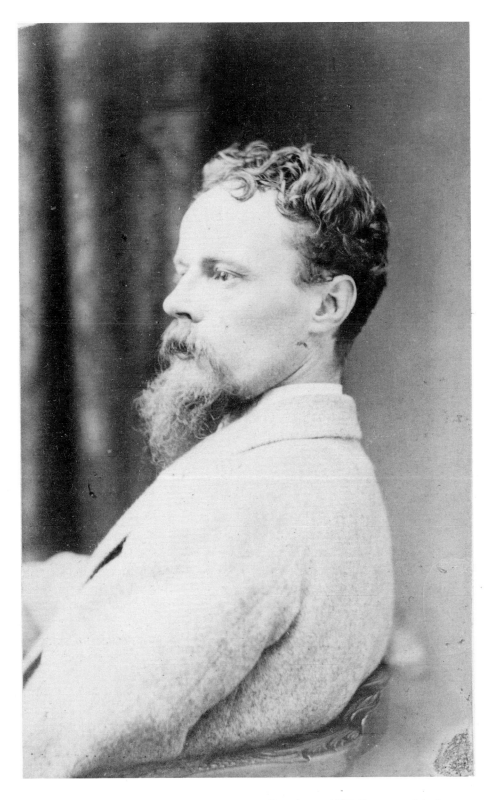

2. C. A. Duval. Photograph of Atkinson Grimshaw. *c*.1870. From an original carte de visite, 9.2 × 5.7 cm ($3\frac{5}{8}$ × $2\frac{1}{4}$ in). Leeds City Art Galleries

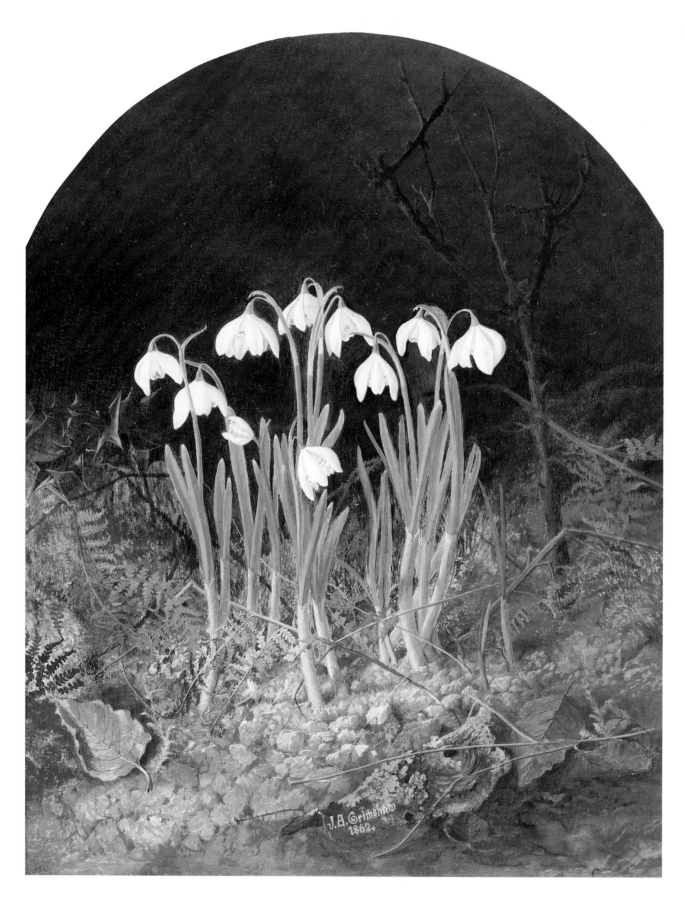

3. *Fair Maids of February*. 1862. Oil on board, 35.6 × 30.5 cm (14 × 12 in). Private collection

THE LEEDS BACKGROUND

The family background of John Atkinson Grimshaw was extremely modest. At the time of his birth in 1836 his father, David Grimshaw, was a policeman in Leeds, but in the early 1840s he moved his family to Norwich in search of better opportunities. For a time Atkinson Grimshaw attended the Grammar School there, but by 1848 the family was back in Leeds. David Grimshaw now became a collector for the Great Northern Railway Company, while his wife kept a grocery shop.

By 1852 the younger Grimshaw was also working for the railways as a clerk. There is no obvious reason why he began to paint in his spare time. No other member of the family had any artistic connections, and his parents' strict non-conformism—they were Baptists—led apparently to Grimshaw's mother's active opposition to his painting, for she threw his paints on the fire and even turned off the gas in his room. During the mid-1850s, Atkinson Grimshaw had no opportunity for special training as an artist, so it must be assumed he began his painting activity by looking at engravings and examining the works of art in local commercial galleries.

The Leeds public had many opportunities to see some of the very best in contemporary painting on show at the town's galleries. The most prominent and successful of the gallery owners was Alexander Hassé who obtained the loan of Holman Hunt's *The Light of the World* in 1859, Henry Wallis's *Death of Chatterton* and J. E. Millais's *The Black Brunswicker* in 1860, and W. P. Frith's *Derby Day* in 1861, as well as watercolours by Turner, Girtin, Copley Fielding and William Henry Hunt. Rosa Bonheur was represented in his gallery in 1862, and Hassé was able to borrow Holman Hunt's *The Finding of the Saviour in the Temple* in 1863.

The existence of several such art galleries in Leeds in the 1850s must owe something to the pioneering work of the Northern Society for the Encouragement of the Fine Arts which had originally been founded in Leeds in 1808, and had survived intermittently until 1839. The Society gave artists, local and national, the chance to exhibit and, more importantly, encouraged local people to buy from the annual exhibition; it also gave those with a collection of paintings and sculpture the chance to lend to occasional loan shows. Among the founding members of the Society was Benjamin Gott, undoubtedly the most successful of the new manufacturers and increasingly prosperous from the 1790s onwards.

Gott's vast new factory at Bean Ing, just outside the town centre, on the River Aire, was one of the wonders of industrial England and Europe. The wealth generated by textile manufacture enabled Gott to buy Armley House, an estate two miles from Leeds, with views from the landscaped Repton grounds towards his factory in the town. The house was remodelled by Robert Smirke in the increasingly fashionable neo-Grecian style, and was filled with paintings, sculpture, fine furniture, drawings, prints and rare books. Gott's financial success brought him honours as mayor of Leeds, as well as a leading place in local society for over forty years. He not only promoted the career of his sculptor relative, Joseph Gott, in Rome, but was also personally acquainted with Sir Thomas Lawrence, two of whose finest portraits were of Mr and Mrs Gott.

After the demise of the Northern Society in 1839, a series of exhibitions was organized in Leeds which continued the idea of mixing works for sale with loans from local collectors. The Leeds Academy of Art mounted two exhibitions in 1853 and 1854 in which over six hundred paintings and sculptures by local as well as national artists were included. In 1856 an exhibition of modern French paintings was shown at the Music Hall with Rosa Bonheur's famous picture *The Horse Fair* as the centrepiece; the whole enterprise was under the direction of the London picture dealer Gambart. Most of the artists were familiar names from the Paris Salon, including Delaroche, Meissonier and Troyen, and the exhibition is an important indication of how much good art was available in the provinces, as dealers began to tour famous paintings and the engravings related to them.

Such exhibitions as these, along with the works on show in local galleries and occasional pictures to be seen at the premises of carvers, gilders and framers, must have presented ideal study opportunities for a young man keen to learn all he could about painting; and, in the early 1860s, in spite of many obstacles, not least from his parents and from his lowly economic situation, Grimshaw took the decision to establish himself as an artist. In this undertaking he was fully supported by his cousin, Frances Theodosia Hubbarde, who had become his wife in 1858.

No doubt a spur for Grimshaw's aspirations was provided by the success of a number of artists who were well known in the Leeds of the 1850s—Joseph and John Nicholas Rhodes, Charles West Cope, Charles Henry Schwanfelder and Edward Armitage—but there was one contemporary Leeds artist whose influence and example must be considered paramount. Apart from being much the nearest to Grimshaw in age, his pre-eminence lay in his intimate connection with the most exciting and controversial art movement of the whole century in Britain: Pre-Raphaelitism. The artist in question was John William Inchbold (born in 1830) whose father was proprietor of the *Leeds Intelligencer*, forerunner of the *Yorkshire Post*.

Inchbold had received some drawing instruction in Leeds before moving to London where he spent some time with the lithographers Day and Haghe before enrolling at the Royal Academy schools. When aged only nineteen he exhibited some watercolours at the Society of British Artists, but by the early 1850s he had made contact with the group of young artists known as the Pre-Raphaelite Brotherhood whose original seven members were J. E. Millais, Holman Hunt, D. G. Rossetti, W. M. Rossetti, Thomas Woolner, James Collinson and F. G. Stephens. Of these, Inchbold was closest to the Rossetti brothers. Very soon he began to paint in line with Pre-Raphaelite principles of exact rendering of nature, with precisely detailed drawing as a means of rejecting the academic idealization which had led artists to generalize nature since the Renaissance.

The Brotherhood saw confirmation of their beliefs in the writings of John Ruskin whose first volume of *Modern Painters* had appeared in 1843. Ruskin had dedicated his book 'To the Landscape Artists of England', yet he decided to champion the Pre-Raphaelites because of their unaffected truth of observation, which fitted in well with his own words addressed to painters:

> From young artists, in landscape, nothing ought to be tolerated
> but simple *bona fide imitation* of nature. . . . [They] . . . should go
> to Nature in all singleness of heart, and walk with her
> laboriously and trustingly, having no other thoughts but how
> best to penetrate her meaning, and remember her instruction,
> rejecting nothing, selecting nothing, and scorning nothing;
> believing all things to be right and good, and rejoicing in the truth.

This declaration of 'truth to Nature', the insistence on detail and finish, brought forward Ruskin as the Brotherhood's champion.

At the Royal Academy in 1855 Inchbold exhibited *At Bolton: the White Doe of Rylstone* (Pl. 4). The painted surface is replete with detail and highly finished. The foreground observation of nature, the moss-covered stones, the twining ivy leaves, the exquisitely painted Wharfedale landscape beyond, all point to a close attachment to Pre-Raphaelite methods and aims. The local colour is applied thinly over a white ground, a technique particularly favoured by Millais and the other artists of his circle.

In the year following Inchbold's Royal Academy success, the Leeds press was to bring his work to their readers' attention. The *Leeds Mercury*, writing of the artist's painting *Mid Spring* commented, 'The knowledge of nature is wonderful, but it seems somewhat hard from so much being given, and that with a second sight intensity.' In 1857 the newspaper again mentioned Inchbold's work, saying that several of his paintings were to be seen at his home and that the artist would gladly show them 'to any of the lovers of art who may call upon him'.

No direct evidence exists that Grimshaw and Inchbold were acquainted, yet as a young man keen to see as much art as possible and to learn by observation and imitation, it is highly likely that Grimshaw would have made it his business to meet this older contemporary with his first-hand details of Pre-Raphaelitism. Inchbold's connections with artists of the Brotherhood and with Ruskin himself from around

4. John William Inchbold. *At Bolton: the White Doe of Rylstone*. 1855. Oil on canvas, 68.6 × 50.8 cm (27 × 20 in). Leeds City Art Galleries

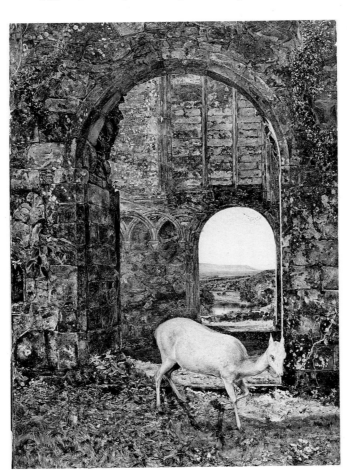

1854 meant that he was ideally placed to communicate the objectives of the movement to his fellow townsman. Moreover, in both 1856 and 1858, Inchbold had been in the Alps with Ruskin, and his application of Pre-Raphaelitism to landscape subjects there was given the critic's encouragement. The undoubted standing of Inchbold, meant that Grimshaw had a successful technique to emulate, and once he had established himself, the evidence of his own paintings speaks of a close interest in Pre-Raphaelite landscape of the type practised by Inchbold. For example, *A Mossy Glen* (Pl. 5) has an overall surface pattern and structure very close to Inchbold's *At Bolton* and other paintings of the 1850s.

Another factor that must have contributed to Grimshaw's resolve to become an artist was the prospect of the support and interest he might reasonably expect from the local middle class. The Leeds of 1861 was an increasingly prosperous Victorian town, its advancement symbolized by the newly built Town Hall, opened by the Queen in 1858. It must be admitted, however, that Charles Dickens's description of 'Coketown' in *Hard Times* might easily have been a view of parts of Leeds at that time:

> It was a town of machinery and tall chimneys, out of which interminable serpents of smoke trailed themselves for ever and ever, and never got uncoiled. It had a black canal in it, and a river that ran purple with ill-smelling dye, and vast piles of buildings full of windows where there was a rattling and a trembling all day long, and where the piston of the steam engine worked monstrously, up and down, like the head of an elephant in a state of melancholy madness.

In the Leeds of the 1850s, a new type of businessman was emerging, personified by the stockbroker Thomas Plint, for whom the paintings of the Pre-Raphaelite Brotherhood in particular seemed to include a most worthy and Christian ideal, that of 'truth to Nature'. Plint himself was a local preacher at East Parade chapel. His collecting activities and close contact with Pre-Raphaelite artists enabled him to acquire 333 oils and watercolours, including many works by leading members of the group, before his tragically early death in 1861. These works were often borrowed by local dealers for exhibition in Leeds, and during his last years Plint had begun to lend paintings to the Leeds Philosophical and Literary Society's annual exhibitions. (In December 1859, for example, he lent several Pre-Raphaelite pictures, among which were Ford Madox Brown's *The Last of England* and two paintings by Arthur Hughes, *The Annunciation* and *The Nativity*.) Moreover, it is quite possible that a man of his evident enthusiasm would have allowed Grimshaw access to his collection and relayed comments from his London artist friends. Grimshaw would, therefore, have had another direct link with those artists closely concerned with Pre-Raphaelitism in its early years a decade before.

Equally important for Grimshaw, of course, was the scale and type of patronage represented by Plint. To a young man contemplating a career as an artist, the existence of keen and wealthy local collectors was not merely an encouragement but almost a prerequisite, and in Grimshaw's case it may be reasonably assumed that the example of Plint (and others like him) was highly influential. Taking into account not only the strong possibility of such patronage, but also the inspiring success of Inchbold and the enthusiastic support of his young wife, Grimshaw thus had adequate reason to abandon his job as a railway clerk, and in 1861 or early 1862 he left the Great Northern Railway. Over the next thirty years he was to produce a body of work which amply justified this decision.

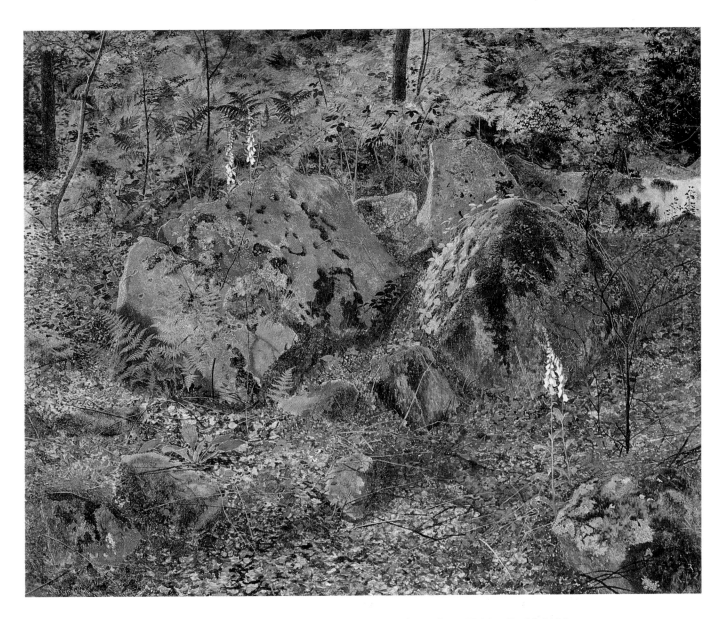

5. *A Mossy Glen*. 1864. Oil on board, 54.7 × 65 cm (21½ × 25⅝ in). Halifax, Bankfield Museum

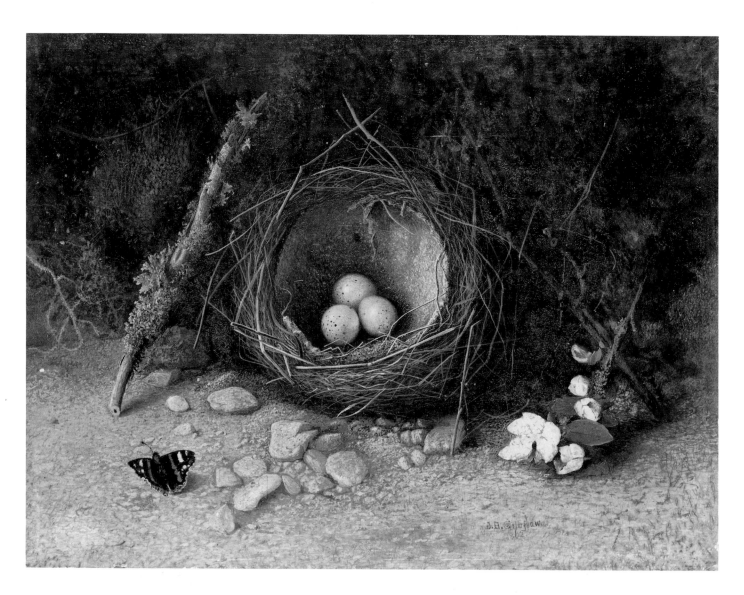

6. *A Thrush's Nest*. 1862. Oil on board, 30.5 × 40.6 cm (12 × 16 in). Private collection

EARLY YEARS

The earliest known paintings by Grimshaw date from 1861. During the first year or so after his decision to earn his living as an artist, Grimshaw produced landscapes and still-life studies showing a love of nature suffused with a strong attention to detail. The softness of handling in a painting such as *From Nature, near Adel* (Pl. 9) implies some lack of understanding regarding pictorial space and the solidity of objects, yet the overall effect is harmonious. When Grimshaw was first married, he and his wife Theodosia would walk from the town centre along the Meanwood Valley to Adel, with the intention of picking up moss-covered stones, leaves, twigs, flowers and feathers for closer study at home. The objects collected would be arranged into still-life compositions which Grimshaw would then paint. From this period date many such studies, often including fruit, birds and butterflies. *Fair Maids of February* (Pl. 3) is just such a painting. Here one might also see the first connection between Grimshaw and Tennyson, whose poem *The Snowdrop* contains the opening lines, 'Many, many welcomes/February fair maid. . .' In these early paintings Grimshaw often signed his name in monogram, perhaps imitating Millais, but he soon changed to *J. A. Grimshaw* which was his usual signature until the late 1860s, although he had used the form *Atkinson Grimshaw* as early as 1863.

From the very beginning opportunities occurred for Grimshaw to exhibit his work. The first painting to be shown was called *Wild Flowers* and was to be seen at the Rifle Volunteers Bazaar at the Leeds Town Hall in January 1862. In May he exhibited another painting, this time at a local commercial gallery—Newton Brothers. *Family Favourites* (now untraced) sounds from the press description to be a most ambitious picture of a young mother with two children, the youngest on a horse, the other playing with a pet spaniel. The subject thus described is very close to the type of work produced by the Leeds artist Charles Henry Schwanfelder, a specialist in animal pictures who was formerly animal painter to George IV, and whose reputation was still strong locally.

Among other Leeds dealers who exhibited Grimshaw were Alexander Hassé in Commercial Street, and William Broadhead in Albion Street. In addition to specialist galleries there were framers, smaller picture dealers and bookshops where a young artist might look for encouragement. An early supporter of Grimshaw was Thomas Fenteman who was principally an antiquarian bookseller, but also the author of a *Dictionary of Painters* and of an unpublished brief life of Charles Henry Schwanfelder. According to the memoirs of the Leeds printer Wesley Petty, Fenteman bought pictures from Grimshaw, 'on the clear, almost statutory, evidence that they were not painted on Sundays'.

At the end of 1862 Grimshaw was represented in the important exhibition at the Philosophical Hall. This was the home of the Leeds Philosophical and Literary Society, a body which in Grimshaw's time enjoyed the strong support of many influential citizens, among whom, until his untimely death, had been Thomas Plint, the stockbroker. Every year (quite apart from any exhibition that may have been mounted in the Philosophical Hall) the society held a conversazione, when objects

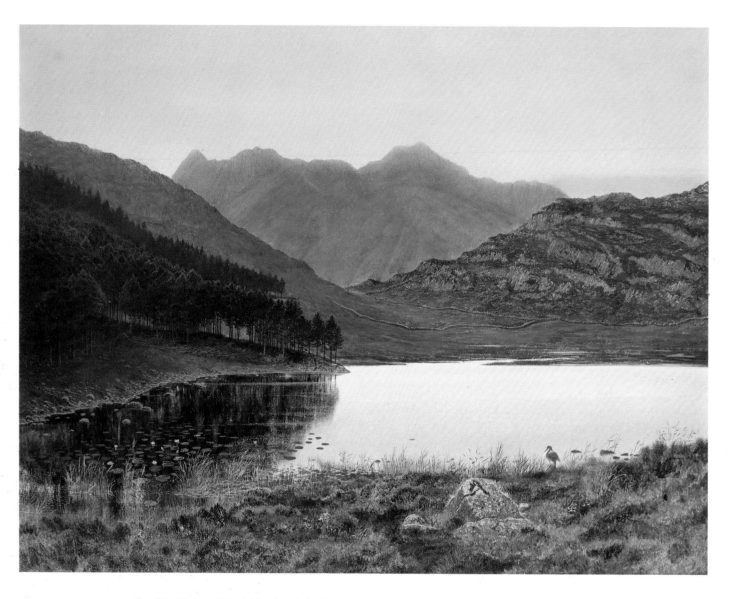

7. *Blea Tarn at First Light, Langdale Pikes in the Distance.* 1865. Oil on canvas, 35.5 × 45.7 cm
(14 × 18 in). Private collection

8. Detail of *Windermere* (Plate 10)

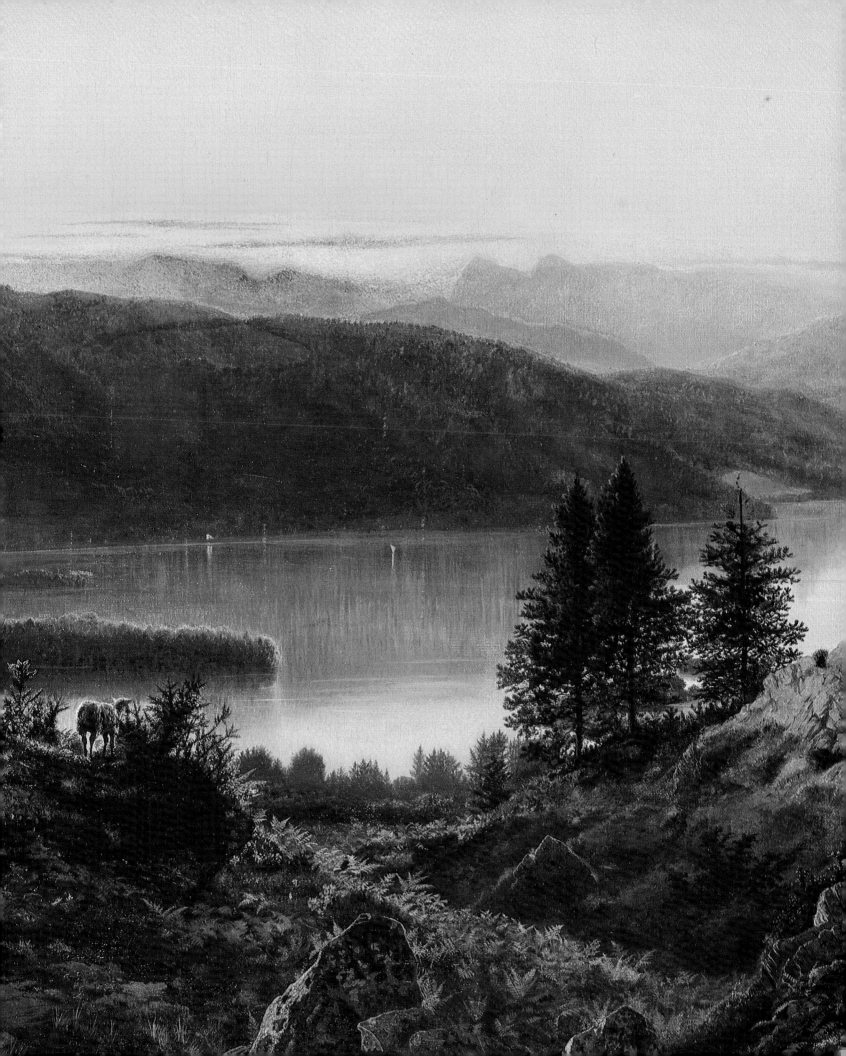

9. *From Nature, near Adel*. 1861. Oil on board, 37.5 × 28.9 cm (14¾ × 11⅜ in). Collection of
Mrs I. G. Appleby

both scientific and artistic would be displayed for discussion. Leeds artists were
often asked to contribute, thus bringing their work to the attention of potential
buyers.

There were six Grimshaw paintings at the 1862 exhibition, still-life and
figure subjects, lent by three local collectors: Edmund Bates, J. D. Holdforth and S.
T. Cooper. The exhibition contained many paintings of note, including watercolours
by W. H. (Bird's Nest) Hunt and D. G. Rossetti (Miss Ellen Heaton of Leeds lent
her *St George and the Princess Sabra*), and there was a strong presence of old master
paintings mixed in with contemporary works. The catalogue of the exhibition was
prefaced by a letter written by Edmund Bates and addressed to J. D. Holdforth, his
fellow lender and collector who was also a prominent silk manufacturer. In his letter
Bates extolled the merit to be earned by organizing public art exhibitions. His essay is
entitled 'Observations on ART PROPER, its Dignity and True Principles, and
Aim . . .'

Bates's text reflects a high moral tone throughout, and he chooses to single
out Grimshaw as a particularly sincere young man:

> Let those who care to do so, carefully study the spirit of those
> pictures, from the tiny sprig of heath in the foreground of his
> 'Woodpigeon', which fully attests in its own way, how lovingly he
> drinks of that Divine Spirit which exclaims with such ever-
> deepening significance: 'Behold the lilies of the field. . . .'

Bates then goes on to praise Grimshaw's decision to abandon 'a distasteful source of permanent competency . . . for the pure love of a higher inspiration. . . .' and concludes, '. . . go on right hopefully in the way of thy choice, with full confidence in the truth of thy mission, and of adequate success.' On the evidence of this eulogy Grimshaw was already fully in the public eye both for his work and for his decision to become an artist.

A year later, in 1863, when he exhibited at the annual conversazione of the Philosophical and Literary Society, the press commented:

> Mr J. A. Grimshaw is another of our local artists who has lately acquired high celebrity, and some new works from his studio graced this temporary exhibition. They have been much admired, especially 'The Bullfinch', and a woodpigeon after a new design.

In a remarkably short time Grimshaw had succeeded in establishing his name.

Grimshaw's early still-life compositions in the years 1861–3 clearly reflected the popularity of those by W. H. (Bird's Nest) Hunt, whose meticulous technique and definition of textures had made him nationally famous. *A Thrush's Nest* (Pl. 6) and such a painting as *A Dead Linnet* were Grimshaw's answer to this popular type of subject. His success in this area was not, however, matched by his early figure paintings in imitation of Millais and others, where the hesitant treatment and scratchy paintwork imply that they were to be seen as experiments in a Pre-Raphaelite idiom which Grimshaw did not yet fully understand.

Until 1863 Grimshaw's paintings were predominantly still lifes with a few landscapes painted in the immediate neighbourhood of Leeds. The handling in such works is competent but the space is shallow, with little sense of atmosphere. The move towards a much more Pre-Raphaelite type of landscape occurred in 1863 with *Windermere* (Pls. 8, 10), which in its brilliant colouring and precise foreground detail marks a significant move by the artist.

At this date, like the members of the Pre-Raphaelite Brotherhood, Grimshaw seldom produced preliminary studies for his pictures, nor would he have worked out of doors, and yet one of the artist's surviving sketchbooks contains a study which shows that he did take on-the-spot notes for use in finished paintings (see Pl. 97). The book is now in the collection of Leeds City Art Gallery.

10. *Windermere*. 1863. Oil on canvas, 48.5 × 100.6 cm (19⅛ × 39⅝ in). Private collection

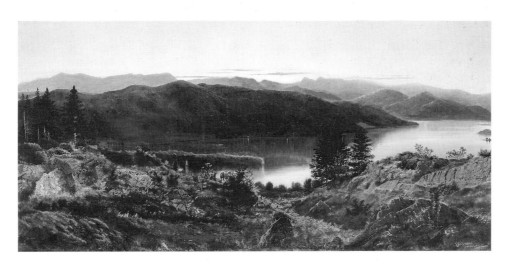

A painting by Grimshaw produced around this time and only recently rediscovered, *Blea Tarn at First Light, Langdale Pikes in the Distance* (Pl. 7), is clearly based on a photograph in an album once belonging to the artist and now at Leeds City Art Gallery. The photograph bears a printed inscription to the effect that it shows the site of Wordworth's 'Solitary', which prompted Grimshaw to add a few lines from the poem on the reverse of his painting. The use of photographs by artists at this date is becoming increasingly documented, and further details of Grimshaw's practice in this connection are given on pp. 110–18.

Ruskin himself had given the new daguerreotype and calotype his early approval, mostly because of the benefits they could give to the artist as an aid to drawing. Thus he could write, 'Amongst all the mechanical poison that this terrible nineteenth century has poured upon men, it has given us at any rate one antidote— the daguerreotype.' In his view, slavish imitation was to be avoided; the photograph existed as an *aide-mémoire*, as a guide to drapery on sculpture or to rock formations in a remote Swiss valley. For Ruskin, the first direct study of nature was still paramount, and yet, as he soon found, the short cuts which photography offered were often too tempting for artists to resist.

Grimshaw had served his apprenticeship to Nature in his early still lifes, now he was to make direct use of photographs in his landscape compositions. The brilliantly coloured *Bowder Stone, Borrowdale* (Pls. 11, 12) is almost certainly based on a photographic source. Here, as in other Lakeland and Yorkshire subjects, everything is brightly coloured and seen in a clear light, presenting a dazzling landscape of a startling, Pre-Raphaelite kind. The handling is delicate and precise, the drawing sharp, the paintwork enamel-like in its hardness.

The achievement of the years 1863–6 justifies the view that Grimshaw, along with J. W. Inchbold, should be considered more seriously as a Pre-Raphaelite landscape artist. If, in Grimshaw's case, there is a somewhat frozen quality to his paintings, an almost airless 'moment of time', he gradually began to combat this by broadening his technique, and by introducing a new feeling for atmosphere and mood.

11, 12. *The Bowder Stone, Borrowdale. c.*1865. Oil on canvas, 40.5 × 54 cm (16 × 21¼ in). London, the Tate Gallery

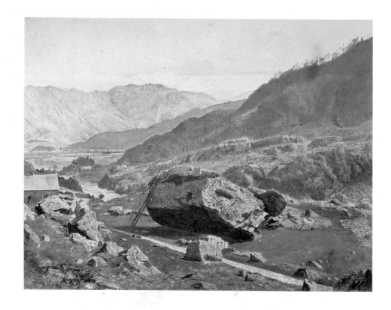

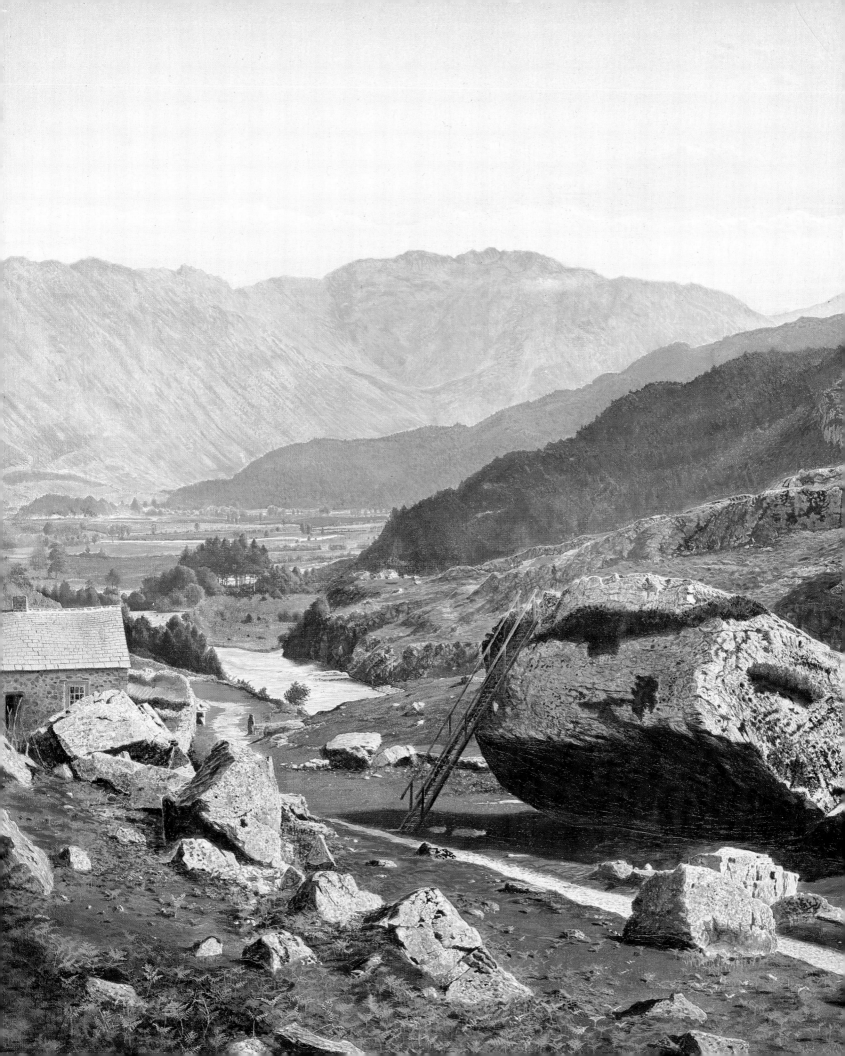

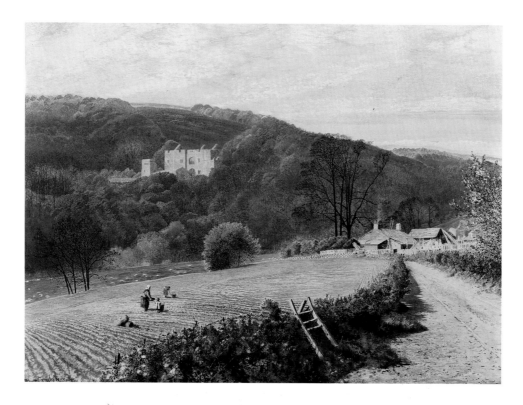

13. *Barden Tower, Yorkshire.* 1868. Watercolour and bodycolour, 39.4 × 54 cm (15½ × 21¼ in).
Chatsworth, Devonshire Collection

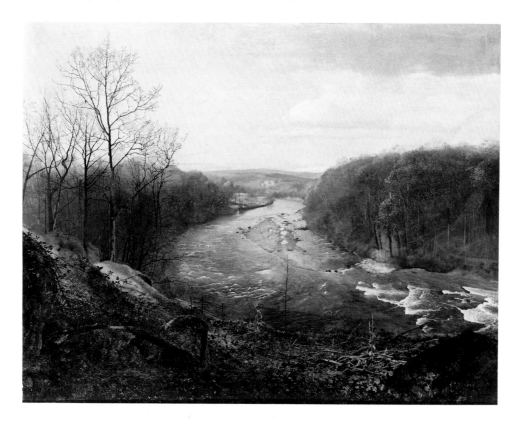

14. *The Wharfe above Bolton Woods, with Barden Tower in the Distance.* 1868. Oil on canvas,
71.1 × 91.5 cm (28 × 36 in). Private collection

15. *Bolton Woods*. 1870. Oil on board, 76.2 × 63.5 cm (30 × 25 in). Private collection

Barden Tower, Yorkshire (Pl. 13) and *The Wharfe above Bolton Woods, with Barden Tower in the Distance* (Pl. 14) both present a greater naturalness which may owe something to the type of landscape popularized by John Linnell, whom Grimshaw was to visit in the mid-1880s at Redhill. Certainly the farmworkers in the fields would have been a popular contemporary subject, embodying the reassuring notion that the rural idyll still survived in a rapidly changing industrialized world. In the same vein, *Bolton Woods* (Pl. 15), with its luxuriant woodland, brilliant sky and nonchalant rabbit on the sunlit footpath, conveys the sense of permanence in the natural countryside, still intact beyond the towns.

Grimshaw frequently includes some element of toil both in his landscapes and townscapes, and hard work is made to seem part of an overall, natural social balance. *Twilight* (Pl. 16) is romantic because of the sense of repose which evening brings, yet it also contains a scene of labour—work in the fields, presented as part of the unchanging order. In *Mary Barton* Mrs Gaskell gives a townsman's view of the country: 'Here in their seasons may be seen the country business of hay-making, ploughing, etc., which are such pleasant mysteries for townspeople to watch.' This emphasis on *mysteries* reinforces the view that contemporaries felt alienated by their new industrial surroundings, and by the disappearance of the rural way of life. Grimshaw was often to reflect this sense of loss in his paintings.

Of all the paintings of the 1860s, the one which perhaps best realizes Ruskin's exhortation to 'go to Nature in all singleness of heart' is the dazzling *Ghyll Beck, Barden, Yorkshire, Early Spring* (Pl. 17). The observation is quite breathtaking. A direct, almost sensual joy in the delights of the countryside is revealed by the

16. *Twilight*. 1869. Oil on board, 39.4 × 53.4 cm (15½ × 21 in). Private collection

depiction of the peaty banks, moss-covered tree trunks, clear, icy waters and the early primrose bravely flowering. This is a veritable hymn to Nature.

Such delight in the outdoors by city dwellers is reflected in two novels of mid-century industrial life, *Hard Times* and *Mary Barton*. Elizabeth Gaskell in *Mary Barton* wrote of Green Heys Fields, Manchester, as a place of escape from industrial life, where nature could be experienced anew by the workers. In *Hard Times* Dickens describes how Sissy and Rachel leave Coketown for a walk in the country:

> Though the green landscape was blotted here and there with heaps of coal, it was green elsewhere, and there were trees to see, and there were larks singing (though it was Sunday) and there were pleasant scents in the air, and all was overarched by a bright blue sky. . . . Under their feet, the grass was fresh; beautiful shadows of branches flickered upon it, and speckled it; hedgerows were luxuriant; everything was at peace. Engines at pits' mouths, and lean old horses that had worn the circle of their daily labour into the ground, were alike quiet; wheels had ceased for a short space to turn; and the great wheel of earth seemed to revolve without the shocks and noises of another time.

In Grimshaw's paintings of this period, the loving, detailed observation gives just such a sense of rediscovery and renewal, and this passage might almost be a description of his *Burnsall Valley, Wharfedale* (Pl. 18), with its shimmering, hazy distance and contrasting careful foreground detail.

Two pictures from the end of this period reflect the change which was about to occur in Grimshaw's work—the move away from brightly-lit landscapes to an interest in evening and night. *Sunset from Chilworth Common, Hampshire*, 1868 (Pl. 20), contains a brilliant evening sky. Here there seems to be an interaction of the differing techniques of oil and watercolour painting, as the sky and middle distance resemble the sort of effects achieved by J. M. W. Turner. The treatment is generalized in the painting of the ferns and trees but much more precise in the furrows of the fields.

17. *Ghyll Beck, Barden, Yorkshire, Early Spring.* 1867. Oil on board, 76.2 × 63.5 cm (30 × 25 in).
Private collection

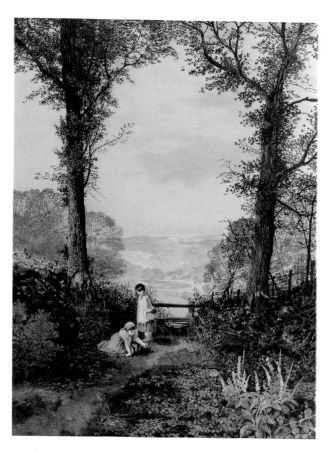

18. *Burnsall Valley, Wharfedale. c.*1868. Watercolour with bodycolour and gum arabic,
25.4 × 19.1 cm (10 × 7½ in). Collection of Mr George Watson

The previous year Grimshaw had painted another sunset scene with a brilliant sky, and also what is considered to be his first night scene, *Whitby Harbour by Moonlight* (Pl. 21). Although the colouring is bright there is clearly a move away from Pre-Raphaelite influence; moonlight and shadows are not conducive to sharp, hard-edged handling. There must also have been a desire on Grimshaw's part to lessen the time spent on each picture, for, by the end of the 1860s he was able to sell oil paintings for £125 and watercolours for £9–£10; growing success evidently led him to broaden his style in order to increase his output. At least twenty dated paintings are known for 1868, twice the number for each year earlier in the decade.

This same year Leeds saw the vast *National Exhibition of Works of Art*, held in the newly completed Gilbert Scott Infirmary building. The exhibition was undoubtedly Leeds's answer to Manchester's *Art Treasures* exhibition of 1857—an example of civic rivalry between the two great northern manufacturing centres. The Leeds exhibition had on show over three thousand paintings and drawings as well as many decorative art objects. Grimshaw was represented by two paintings lent by Edward Simpson: *The Seal of the Covenant* (see Pl. 93) and *The Heron's Haunt*; both reveal a new interest in atmospheric effects. The previous year Grimshaw and his wife had joined the Roman Catholic Church, and family tradition relates that *The Seal of the Covenant* was of special significance to the artist as a kind of pledge to God. Moral meanings in Victorian paintings are frequent, so that one might also see relevant religious truths in *Ingleborough from under White Scar* (Pl. 23), with its depiction of a wild, rocky place where the Act of Creation and theories of evolution might both be considered. From this period dates the use of a cross after the signature and date on

Grimshaw's paintings. Whether this has a moral or religious significance is unclear. Later, when Grimshaw's own adherence to Roman Catholicism lapsed, the cross is surmounted by a triangle for which no satisfactory explanation has been found.

By the mid-1860s Grimshaw's early success enabled the family to move from the centre of Leeds to the more pleasant surroundings of Cliff Road, Woodhouse, on the west of town, where it adjoins Woodhouse Ridge. This area, with its high stone walls along the roads, spreading tree branches and secluded villas, has changed little today.

The culmination of this period of Grimshaw's career is undoubtedly *Autumn Glory: The Old Mill, Cheshire* (Pls. 22, 24), set in the grounds of Dunham Massey. It is a surprise to realize that this is a moonlight scene, so strong is the light. Although the painting is conceived as a night scene, the debt to the artist's early days is still being paid—every leaf, twig, mossy stone and bramble proclaims 'truth to Nature'. The painting may involve the use of photographs, but the final effect is anything but frozen or still; here the depths of the woods seem to breathe with hidden life, containing much more of a sense of mystery than the earlier Lakeland views; there is also a new and disturbing quality in the very emptiness of the scene. The change which this painting shows, demonstrates the artist's own romantic outlook which was becoming increasingly poetic.

Grimshaw's early success in these years has been seriously underrated, partly because, until recently, the 1860s paintings were relatively unknown. In spite of a change of style by the end of the decade—from meticulous detail, high finish and bright colour to a more sombre palette—the interest in nature always remained.

By 1870 Grimshaw was well enough regarded as an artist for him to look round for a home which could fulfil his expectations as an important local figure. He found his ideal location just outside Leeds, two miles east of the town centre by the River Aire at Knostrop Old Hall, a seventeenth-century manor house (Pl. 19). The romantic in Grimshaw was at last able to feel at home. A contemporary photograph shows him as the new master of the Hall, serenely regarding all the prospects of a successful Victorian artist now opening before him (see Pl. 2).

19. J. Wormald. Photograph of Knostrop Old Hall. *c.*1890. 29.3 × 24.2 cm (11½ × 9½ in). Leeds City Libraries

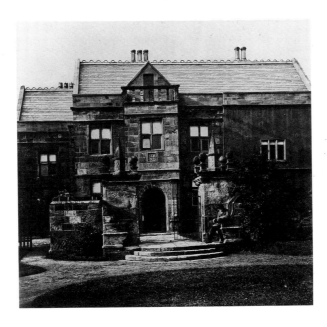

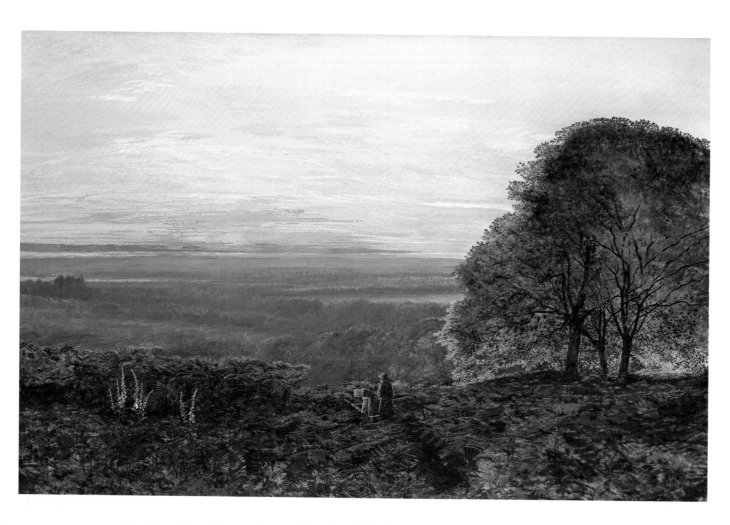

20. *Sunset from Chilworth Common, Hampshire*. 1868. Oil on canvas, 39.5 × 60 cm (15½ × 23½ in).
London, Owen Edgar Gallery

21. *Whitby Harbour by Moonlight*. 1867. Oil on canvas, 61 × 78.2 cm (24 × 31 in). Private collection

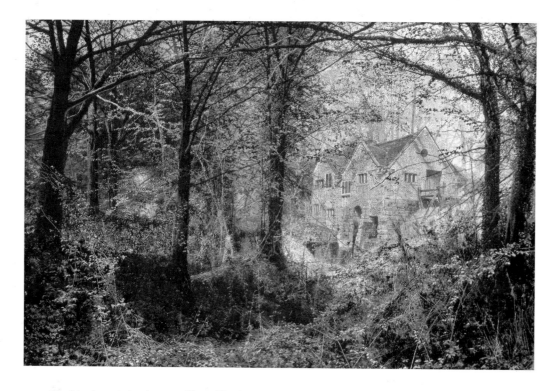

22, 24. *(opposite)* *Autumn Glory: The Old Mill, Cheshire.* 1869. Oil on board, 62.3 × 87.5 cm
(24½ × 34½ in). Leeds City Art Galleries

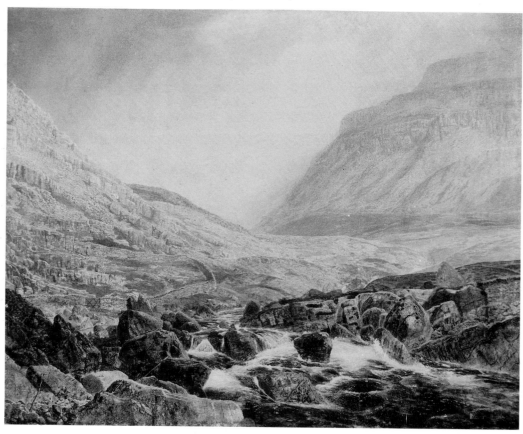

23. *Ingleborough from under White Scar.* 1868. Oil on canvas, 72 × 91.5 cm (28¼ × 36 in).
Bradford Art Galleries and Museums

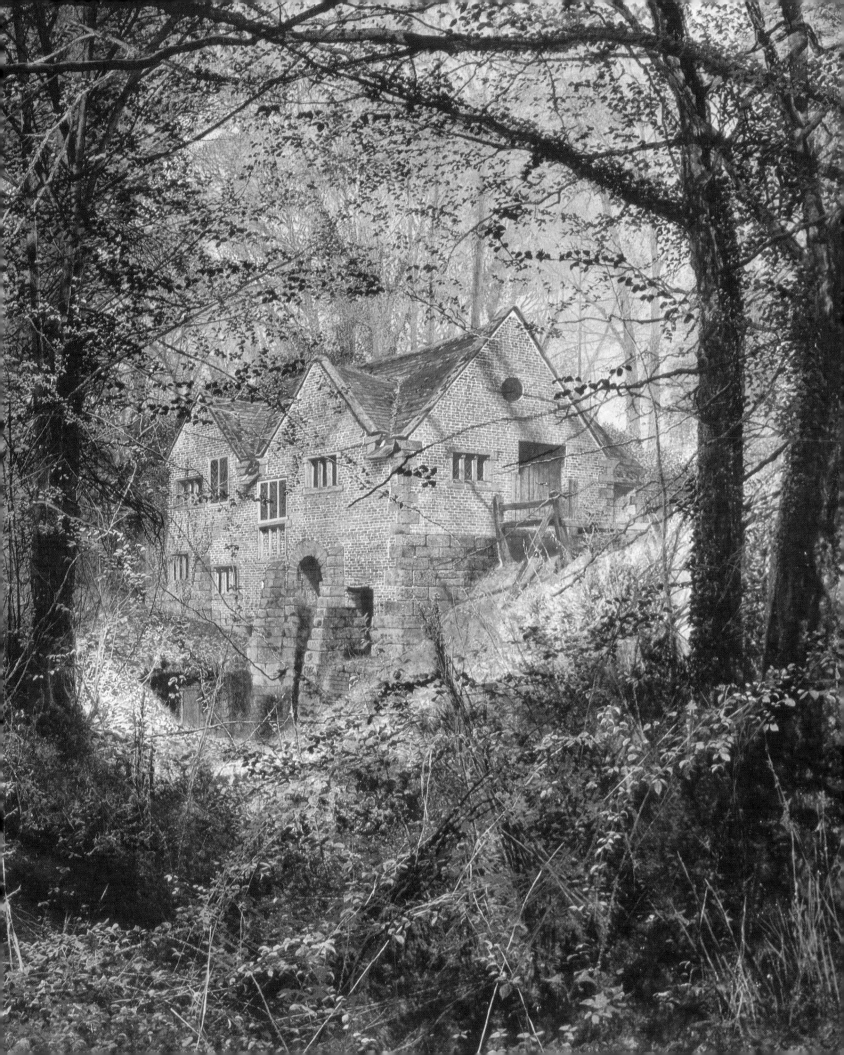

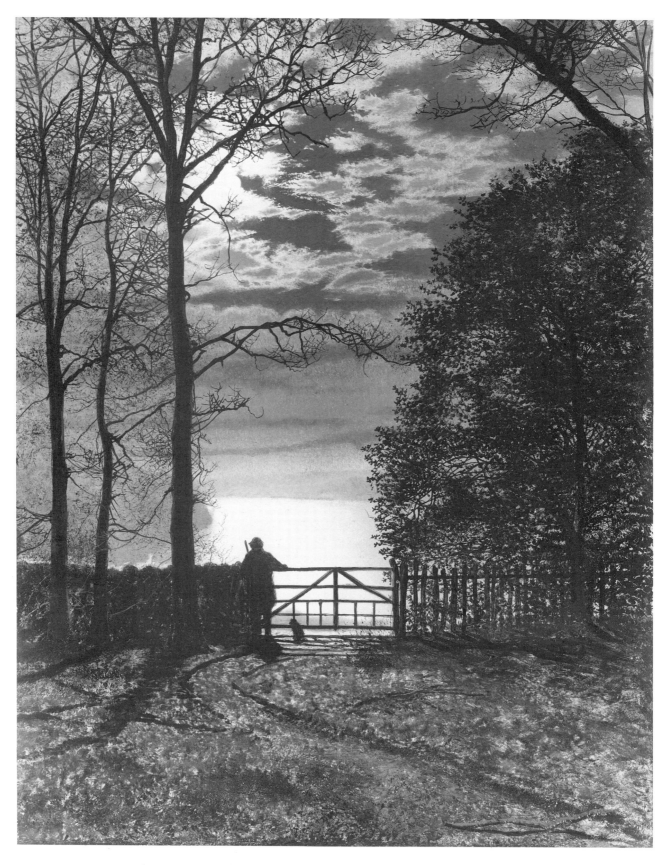

25. *Under the Hollies, Roundhay Park, Leeds*. 1872. Oil on board, 54.6 × 43.8 cm (21½ × 17¼ in).
Private collection

KNOSTROP OLD HALL

The 1870s were the period of Grimshaw's greatest success, with an increasingly popular local reputation, soon to spread to London when the art dealer William Agnew began to buy and sell his paintings. Further success came in 1874 when a picture by Grimshaw was accepted at the Royal Academy. From 1876 he was able to rent a second home on the coast at Scarborough where he portrayed the town in a wide-ranging series of paintings and drawings. During this period the scope of his painting extended from the early 'moonlights' to include elegant, modern-life figure paintings, neo-classical subjects and pictures from literature and legend. His contacts with men from the theatrical and literary world also gave him an increased standing socially and even the reputation of a 'bohemian'.

When Grimshaw took over the tenancy of Knostrop Old Hall, it was to be his main home for the rest of his life. In a painting clearly intended to celebrate this move, he painted a fantasy composition of the house, calling it *Knostrop Hall, Early Morning* (Pl. 28). The Old Hall is made to look very grand, with the addition of an extra brick wing complete with oriel window. The autumn view, seen in bright sunshine, presents a happy mood, but one which has troubled undertones suggested by the dead leaves, the pile of broken flower pots and the dead stalks of summer plants. There is definitely a feeling of change—the decay of all earthly things which often permeates Grimshaw's paintings.

The artist's well-known love of Tennyson's poetry seems to be reflected in many subjects where night, overgrown gardens, and empty, mysterious houses are preferred to sunshine and more obviously inhabited dwellings. His painting *The Deserted House* (Pl. 26) is an apt complement to Tennyson's poem of the same name:

> All within is dark as night:
> In the windows is no light;
> And no murmur at the door,
> So frequent on its hinge before.

The early 1870s witnessed in particular the development of the 'moonlights' which were to become synonymous with Grimshaw's name. The care which went into the best of these subjects was just as great as that taken in his early Pre-Raphaelite type of paintings. The change from brilliant daylight to moon-washed night is nowhere more apparent than in *Tree Shadows on the Park Wall, Roundhay Park, Leeds* (Pl. 27). In this picture, moonlight floods down through a tangle of branches, casting shadows over the walls and roadway. An eerie light pervades the whole composition, enveloping the solitary female figure walking along the road.

At this time the Roundhay Park estate had only just been bought by the Leeds Corporation, and as the Town Council was seeking to promote the Leeds Improvement Bill in Parliament, in order to open the estate as a public park, Grimshaw was asked to produce three paintings to provide the parliamentary committee with some idea of the park's appearance. Rather surprisingly night scenes were painted, not an aspect which most people would normally see.

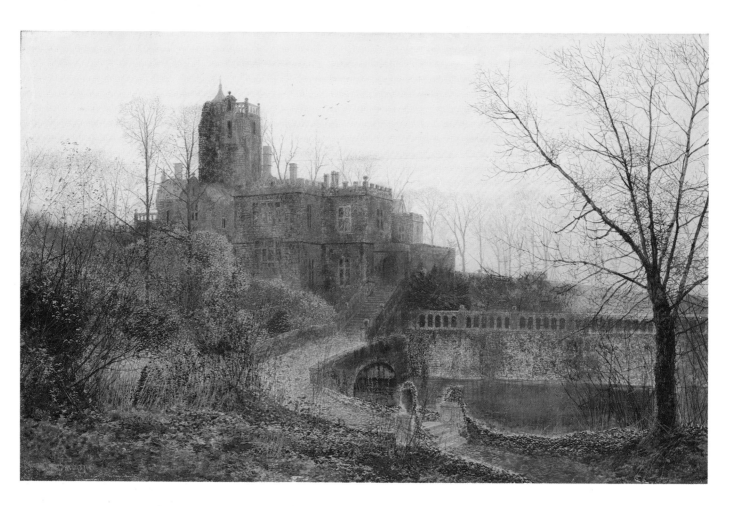

26. *The Deserted House*. 1871. Oil on board, 29.2 × 45.7 cm ($11\frac{1}{2}$ × 18 in). Private collection

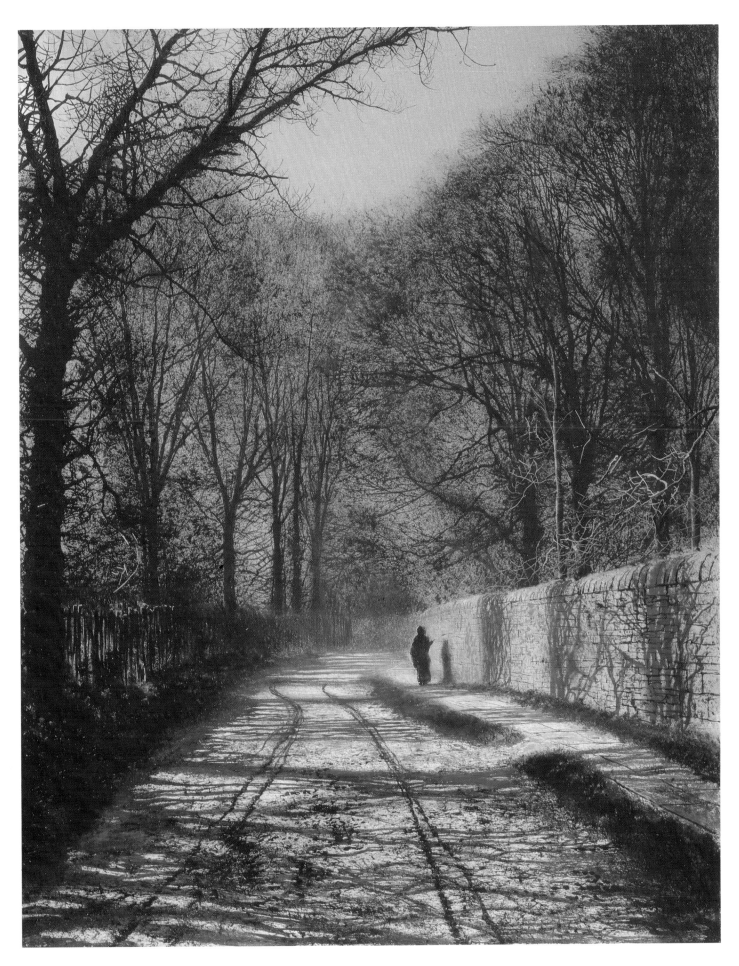

27. *Tree Shadows on the Park Wall, Roundhay Park, Leeds*. 1872. Oil on card, 55.2 × 44.2 cm
(21¾ × 17⅜ in). Leeds City Art Galleries

One of these three pictures, *Full Moon behind Cirrus Cloud from the Roundhay Park Castle Battlements* (Pl. 32), was singled out for comment by the *Leeds Mercury*:

> . . . the lake is seen from the ivy-fringed battlement of the ruined tower, and appears in the deceptive haze to stretch unbroken to the horizon; the interlocking boughs of the near trees, in their winter nakedness, being carefully painted; while the more distant clumps are broadly massed in purple shadow.

The mood here is undoubtedly poetic, with an observation of night-time cloud formations which Ruskin would have appreciated. In volume one of *Modern Painters*, he had written extensively on clouds, with especial reference to Turner: 'There is scarcely a painting of Turner's in which serenity of sky and intensity of light are aimed at together, in which these clouds are not used, though there are not two cases in which they are used altogether alike.' Ruskin was referring to Turner's depiction of high-lying cirrus; he believed such use to have been the first in European art. In his Roundhay Park picture, Grimshaw successfully achieved the effect of this particular cloud formation, but usually preferred fluffy cumulus in his night scenes (Pl. 25).

Two other moonlight paintings of the park are among Grimshaw's finest. The estate contained the 'Waterloo Lake' (excavated from a former quarry following the Napoleonic Wars), a smaller lake, a cascade through a rocky chasm, a dam, and a folly in the form of a ruined castle keep. These surroundings inspired Grimshaw to give of his best in *Waterloo Lake, Roundhay Park, Leeds* (Pl. 31). Although the painting is small, the placing of the figure, the fence and overhanging branches could not be more finely done. This lyrical mood is again perfectly achieved in *Meditation* (Pl. 35), painted around 1875 and bought by the Harding family of Leeds, notable collectors and benefactors of the town. Here the lonely figure standing by the misty lake invites interpretation, though Grimshaw seldom set out to paint a story. The place of women in Victorian society was never a direct concern of his, but as his pictures were of modern life, they often reflect the ambiguous position of contemporary women—placed on a pedestal as a guardian of the home, and yet having no political and few legal rights.

The main concern of Frances Theodosia Grimshaw (known as Fanny) was motherhood and the home. She was to bear fifteen children in all, although only six reached adulthood. Her role was, therefore, that of a typical Victorian wife, yet her strength and support were crucial to Grimshaw's success as an artist. For a brief period in the mid-1870s she may have been the model for a group of paintings which featured the fashionable woman 'at home'.

As a setting for these Knostrop paintings Grimshaw chose his own house, the familiar rooms, the garden, the conservatory. Why he suddenly decided to paint such a series is unknown, except that he may have felt he was now capable of branching out into a new genre that was then being treated so successfully by his exact French contemporary, James Tissot. Although Grimshaw used his wife for the model and also portrayed his own home, the fact that the pictures were put on the market as soon as they were completed, indicates that they were purely commercial ventures, with no particular personal relevance. Until recently this series was only known from contemporary press notices, but now most have been rediscovered. They reveal Grimshaw's skilful observation as well as the technical expertise seen originally in the early still lifes and Lakeland subjects. This 'truth to Nature' was now to be transferred to the figure and its interior setting.

In the early 1860s Grimshaw's figure paintings had been extremely hesitant, more in the way of exercises after such pictures as Millais's *Mariana*. Now Grimshaw was to return to portraying women, not as subjects from literature but in modern dress. However, they were not taken from the world of *nouveau riche* society, as were Tissot's fashionable ladies, and whose portrayal in his paintings was often capable of several meanings. The most elaborate painting in the Knostrop group is *Summer* (Pl. 36), which can be seen as a sort of modern-life *Mariana*, but instead of conveying a sense of boredom or stifling oppression, Grimshaw's painting is a celebration of light and colour. His observation of textures, the surface gleam on the furniture and ceramics, even the ruckle in the rug show his increased technical mastery. There is no apparent meaning in the painting, other than a display of the artist's powers, unless the model herself is to be seen as an 'object', a highly desirable acquisition to be shown alongside the other possessions in the room.

The companion to *Summer*, a painting called *Spring* (see Pl. 1), has recently appeared in the saleroom and presents a much more carefree picture of an early-morning scene with a lady tending her plants. The trappings of the room are well-to-do with a hint of exoticism in the golden screen and parasol. Through the window can be seen the Knostrop Hall garden where Grimshaw was to paint another of this series, *In the Pleasaunce* (Pl. 44). This picture features Mrs Grimshaw holding a Japanese parasol, and is the subject of a note in the Leeds sketchbook, 'must paint Fanny in the garden' (the only reference to the series by the artist). The same sketchbook contains lists of exotic plants which Grimshaw bought for the Knostrop conservatory, used as the setting for *Il Penseroso* (Pl. 46), where the lady of the house is surrounded by hothouse specimens. The composition shows Grimshaw at his most Tissotesque, and is reminiscent of the French artist's *The Bunch of Lilacs*.

Although Grimshaw obviously looked at Tissot's paintings there is no direct evidence that the two men knew each other. In 1875 the *Yorkshire Post*, referring to *A Question of Colour* (another of the Knostrop group), stated that 'it . . . might have been conceived and painted by Tissot, except that the detail work is more complete and the texture-painting much finer than we have been accustomed to see in M. Tissot's recent pictures.' Unfortunately the work is presently untraced, but we do know that its subject is a lady in a fashionable interior, reclining on a sofa before a golden screen and choosing different coloured wools and silks. She is dressed à la Tissot in a black and white striped gown, the whole room rich with decorative trappings.

This interest in Tissot continued beyond the 1870s. In *Autumn Regrets* (Pl. 33), one is reminded of portraits of Tissot's mistress, Mrs Newton, painted in their St John's Wood home (Pl. 30). Tissot's frequent use of a background of chestnut leaves was a feature which Grimshaw himself took up in *Snowbound* (Pl. 29), and *My Wee White Rose* (Pl. 39). In the latter painting there is even a suggestion of Renoir, with the tightly handled forms and enamel-like surface of the flesh areas.

The final picture of the Knostrop group was started in 1876 but remained unfinished until 1885. This painting, *Dulce Domum* (Pls. 34, 40, 110), provides a clue to some of the underlying tensions of such domestic scenes as a whole, a bitter-sweet counterpart of 'Home, Sweet Home' so beloved of Victorian contemporaries. The reverse of the painting carries the following inscription:

Dulce Domum—Harmony. Painted by Atkinson Grimshaw at his home Knostrop Hall, Leeds, Yorks. Commenced and named 1876. Finished January 1885. Painted as a sequel to a picture called 'A Question of Colour' by the same painter and mostly painted under great difficulties, but by God's grace finished 1885. LABOR OMNIA VINCIT.

28. *Knostrop Hall, Early Morning.* 1870. Oil on canvas, 59.7 × 90.2 cm (23½ × 35½ in). London, Richard Green Gallery

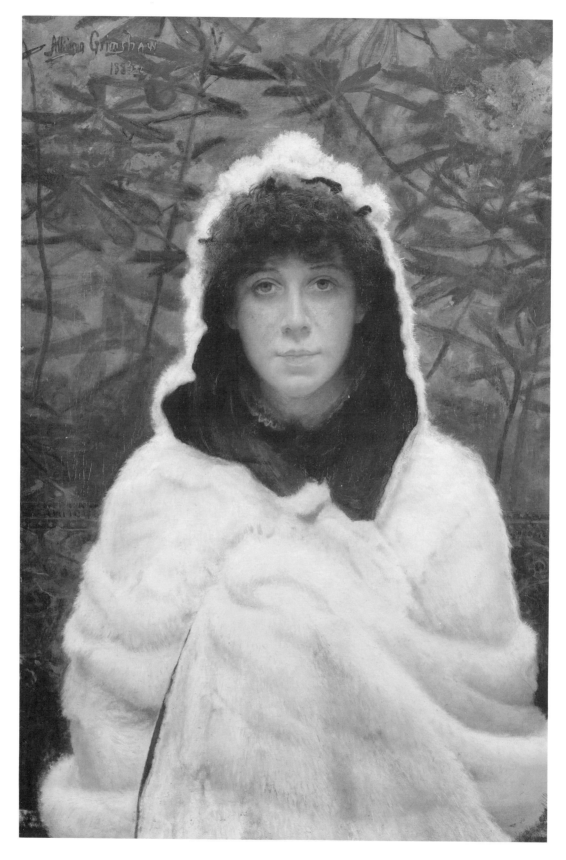

29. *Snowbound*. 1883–4. Oil on canvas, 76.2 × 50.8 cm (30 × 20 in). London, Richard Green
Gallery

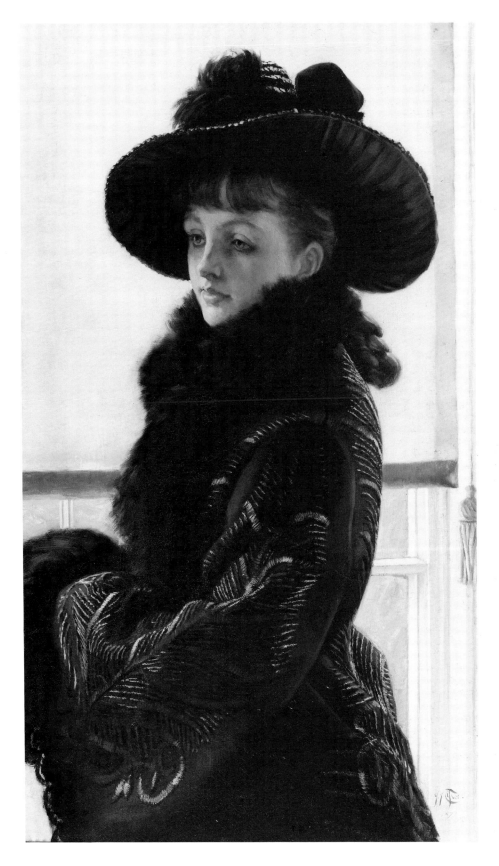

30. James Tissot. *Portrait of Mrs Kathleen Newton (Mavourneen)*. 1877. Oil on canvas,
90 × 51 cm (35½ × 20 in). London, Owen Edgar Gallery

31. *Waterloo Lake, Roundhay Park, Leeds*. 1872. Oil on board, 21.6 × 33.6 cm (8½ × 13¼ in).
Private collection

32. *Full Moon behind Cirrus Cloud from the Roundhay Park Castle Battlements.* 1872. Oil on board,
43 × 54.5 cm (17 x 21½ in). Collection of Mr Harry Patterson

The inscription is a rare comment from Grimshaw, and one which poses many questions regarding his personal life. The defiant 'work conquers all' hides who knows what struggles with family problems, painting difficulties and the supposed financial crisis which struck at the end of the 1870s. From our limited sources we do know that in 1874 there had occurred the deaths of three of Grimshaw's children. Such tragedy in the midst of his success makes his story similar to that of many other Victorian families; nevertheless, as an artist, he was still detached enough to paint the face of his daughter Gertrude as she lay on her death-bed.

On its completion *Dulce Domum* was exhibited at the Royal Academy. Reviewing the annual exhibition of 1885, the *Art Journal* regarded the painting as 'a bold and not altogether unsatisfactory attempt to revive the tradition of the Pre-Raphaelite Brotherhood.' The critic of *The Times* gave it a more mixed reception:

> But, perhaps, the most elaborate piece of execution in the room is the rather absurdly named 'Dulce Domum' (947) of Mr Atkinson Grimshaw, which represents, not, as might be supposed, a set of schoolboys singing their breaking up song, but one sentimental lady sitting in an easy chair while another plays the piano. For the subject and the composition of the painting there is little to be said, but there is hardly to be found in the exhibition such another piece of sheer painting as the dress of the lady in the foreground.

Later the picture, priced at £1,000, was exhibited in Manchester, where it was bought by Grimshaw's Leeds patron Walter Battle.

Dulce Domum is certainly a *tour de force* of observation, of light on surfaces where even the doorknobs and mirrors contain gleaming reflections; the focus of the painting is the extraordinary luxuriance of the main figure's dress, while the model herself has a most convincing ease and naturalness. In 1887 the critic and poet T. W. H. Crosland wrote a poem about *Dulce Domum*; the following extracts pick out features of the Knostrop home:

> Curious old-world furnishings,
> And a voice that dreamily sings
> The sweet old Winton hymn,
> 'Dulce Domum'.
>
> Rich, rare-hued tapestries,
> Mirrors, and pictured saints,
> Whereon the half-light paints
> Strange iridescences
> That quiver, and glimmer, and start,
> Like the wings of dragon flies
> Lit with the new spilt dyes
> Of a sunbeam's broken dart.
>
> ———
>
> This house is full of strange memories,
> Wondrously strange, God-wot—
> Dim wraiths of woe and ghosts of tragedies,
> But they disturb her not.

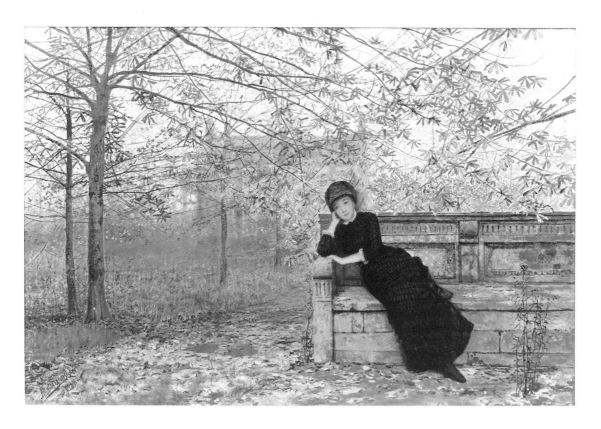

33. *Autumn Regrets*. 1882. Oil on canvas, 61 × 91.5 cm (24 × 36 in). Gateshead, Shipley
Art Gallery

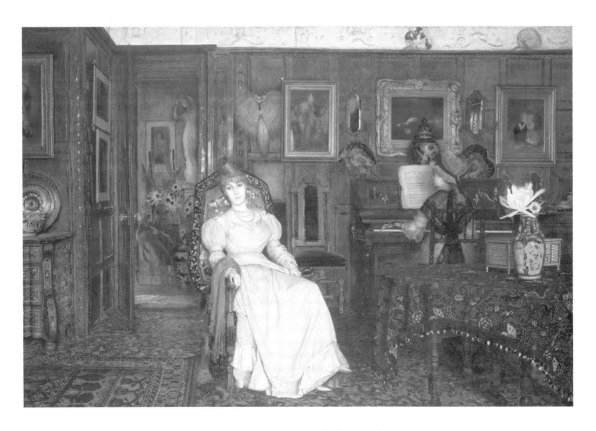

34. *Dulce Domum*. 1876–85. Oil on canvas, 83 × 122 cm (32¾ × 48 in). Private collection

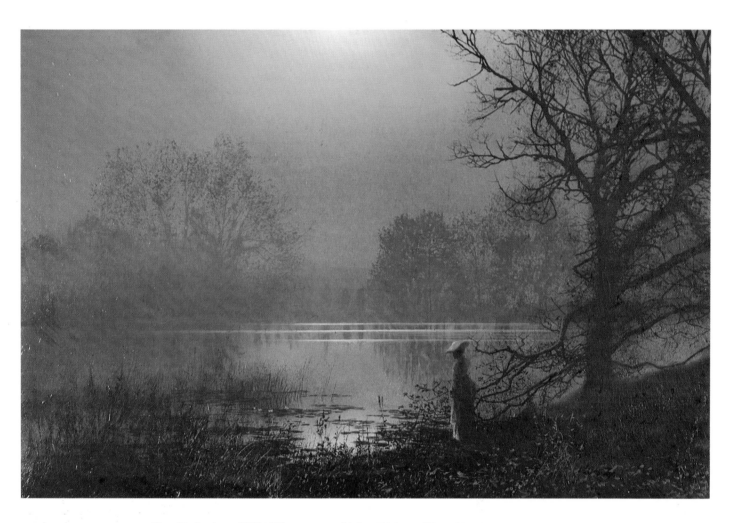

35. *Meditation*. *c*.1875. Oil on canvas, 50.8 × 76.2 cm (20 × 30 in). Private collection

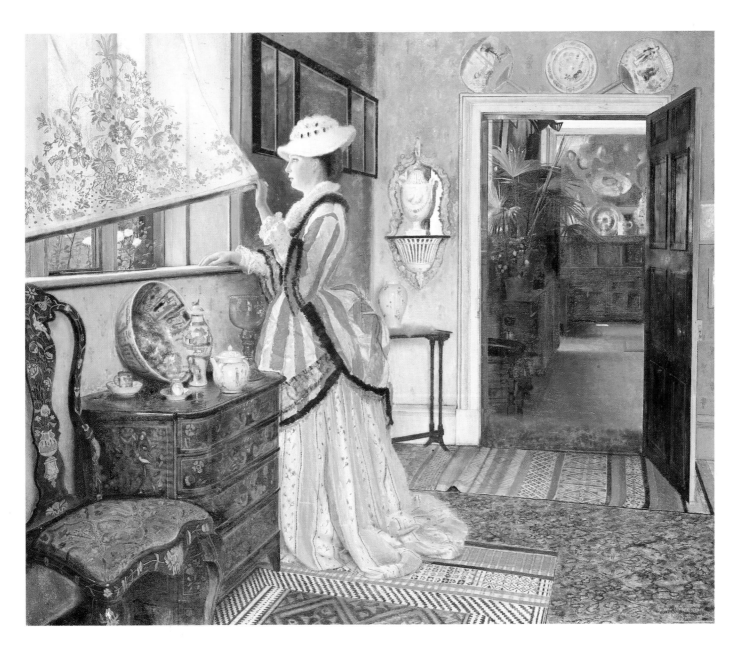

36. *Summer*. 1875. Oil on canvas, 63.5 × 76.2 cm (25 × 30 in). Private collection

37. *Scene at the Theatre. c.*1880–90. Pencil with ink, 12.2 × 18.2 cm (4¾ × 7⅛ in). Leeds City Art Galleries

For Grimshaw, his home at Knostrop Hall symbolized everything that was most sought after in Victorian daily life. In this context John Ruskin can be relied upon to provide the key to this domestic need. In *Sesame and Lilies* he wrote:

> This is the nature of home—it is the place of Peace; the shelter,
> not only from all injury, but from all terror, doubt and division.
> In so far as it is not this, it is not home; so far as the anxieties
> of the outer life penetrate into it, and the inconsistently minded,
> unknown, unloved, or hostile society of the outer world is
> allowed by either husband or wife to cross the threshold, it
> ceases to be home.

The Knostrop figure paintings can be seen as celebrations of this peaceful domesticity, free from the cares of work or the problems of an increasingly urban society. Whatever dilemmas lay beneath *Dulce Domum*—the sense of time passing, of old memories, some sad some not, 'Dim wraiths of woe and ghosts of tragedies'— this painting holds a special place in Grimshaw's *œuvre*.

Some indication of the artist's growing prosperity during his first decade at Knostrop may be gathered from the census returns, which in 1871 list one servant living in, whereas by 1881 there was a cook as well as a servant-girl. Grimshaw is reputed to have lived in some style and to have kept a carriage and pair; and while a lawsuit in 1877 refers to his non-payment for silver harnesses for two ponies, the groom and coachman he employed further reflect the success which he had achieved. Moreover, Knostrop during this period was a centre of entertainment for visiting actors and other artists. Obituary notices refer to Grimshaw's friendship with the sculptor Sir Joseph Boehm, the comic actor J. L Toole and many others who were introduced to him by Wilson Barrett, actor-manager of the Leeds Grand Theatre. Grimshaw was even to paint a scene from a play staged at the Grand, *Jane Shore*, and also drew some studies after a classical drama staged there (Pl. 37). The play is unidentified, but could have been *Claudian*, a romantic drama seen at the Grand in August 1889.

It was probably through Wilson Barrett that Grimshaw met Miss Agnes Leefe, an actress at the Grand Theatre, who was to move to Knostrop Hall in the early 1880s, as the artist's model and studio assistant. There was no suggestion of impropriety: in fact, Miss Leefe became a companion both to the children and to Mrs Grimshaw. She is reputed to have been the model for *Iris*, as well as for some of the other portraits and figure pieces of that period, when Grimshaw began to produce more subjects from myth and literature to follow his Royal Academy work of 1874, *The Lady of the Lea*. He seems to have been especially attracted to the legend of the *Lady of Shalott*, as well as to the *Iris* theme.

During the 1870s Grimshaw's paintings occur frequently in the stock-books of the London art dealers, Thomas Agnew and Son, who at that time also had galleries in Manchester and Liverpool, as well as connections in Glasgow. This meant that Grimshaw paintings shown in London were to be seen in the provinces along with other leading artists of the day, among them Tissot who was also included in the third major Leeds exhibition of this period, the *Yorkshire Exhibition of Arts and Manufactures*, held in 1875. There he was represented by a painting called *Embroidery*, which may have given Grimshaw the idea for his picture *A Question of Colour*, painted a year later.

At Leeds in 1875 Grimshaw showed five canvases, including *Cathedral, St Pierre, Caen*. It is probable that this was based on a photograph or engraving if, as has usually been assumed, Grimshaw made only one trip abroad, when he escorted the children's governess, Mrs Ruhl, back to Germany in 1878. As a result of that trip, he painted several versions of *Rouen at Night* (Pl. 38).

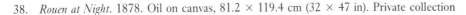

38. *Rouen at Night*. 1878. Oil on canvas, 81.2 × 119.4 cm (32 × 47 in). Private collection

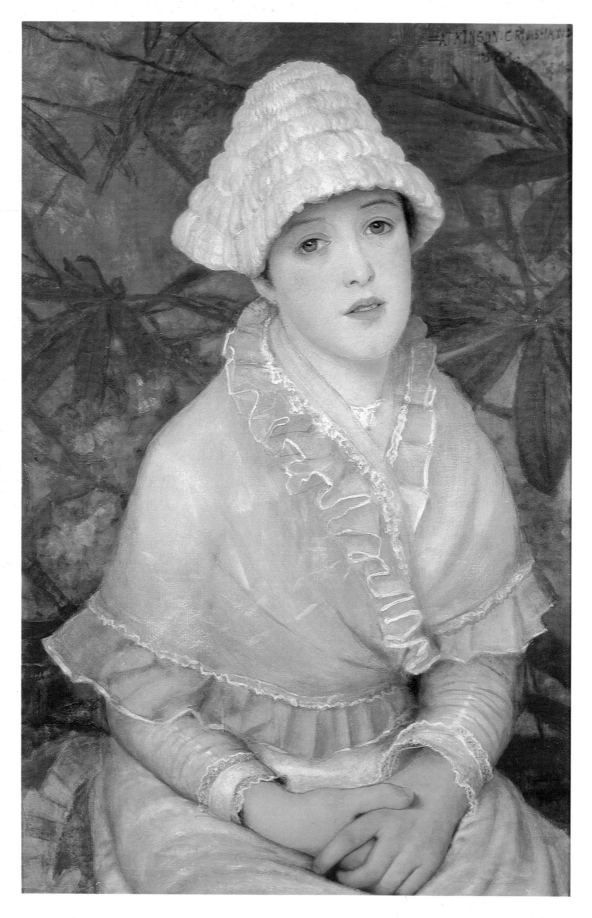

39. *My Wee White Rose*. 1882. Oil on canvas, 76.5 × 48.2 cm (30⅛ × 19 in). Collection of Mrs I. G. Appleby

40. Detail of *Dulce Domum* (Plate 34)

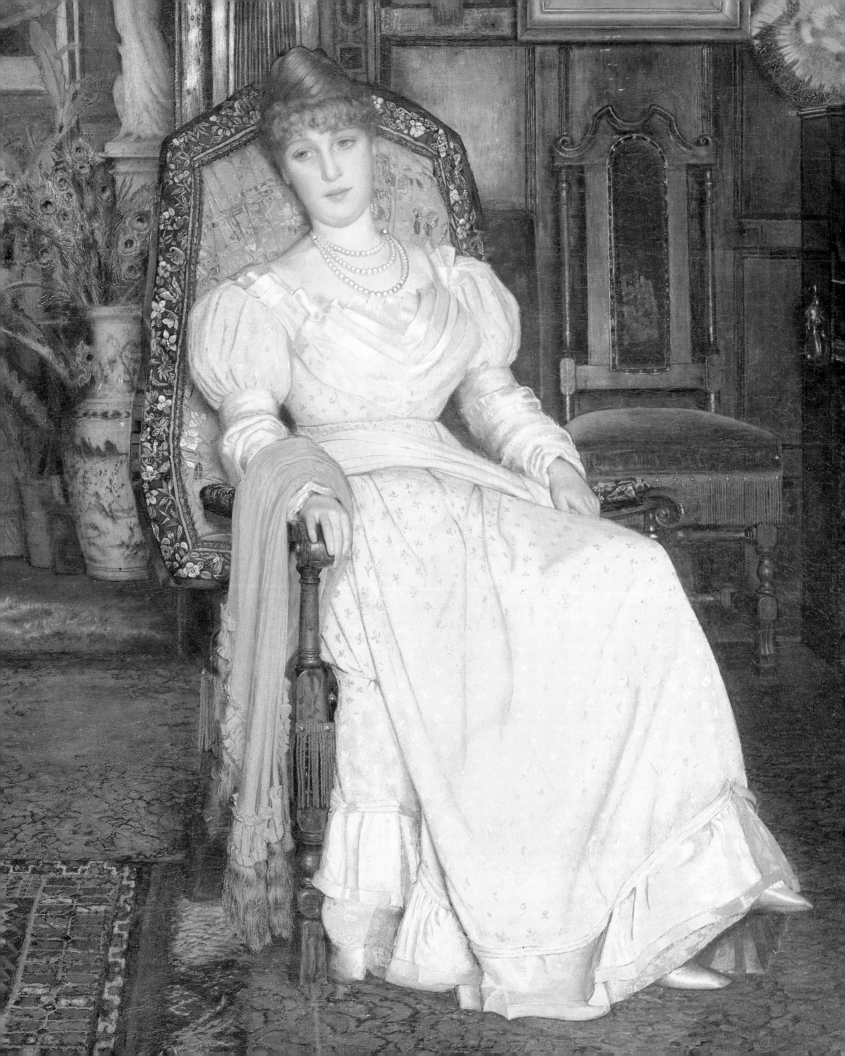

41. *Two Thousand Years Ago.* 1878. Oil on canvas, 75 × 127 cm (29½ × 50 in). London, Owen Edgar Gallery

42. Lawrence Alma-Tadema. *Pleading.* 1876. Oil on canvas laid on panel, 21.5 × 35.6 cm (8½ × 14 in).
City of London, Guildhall Art Gallery

43. *Fiamella.* 1883. Oil on canvas, 61 × 45.7 cm (24 × 18 in). Bradford Art Galleries and Museums

44. *(overleaf)* *In the Pleasaunce.* 1875. Oil on canvas, 45.7 × 73.7 cm (18 × 29 in). Private collection

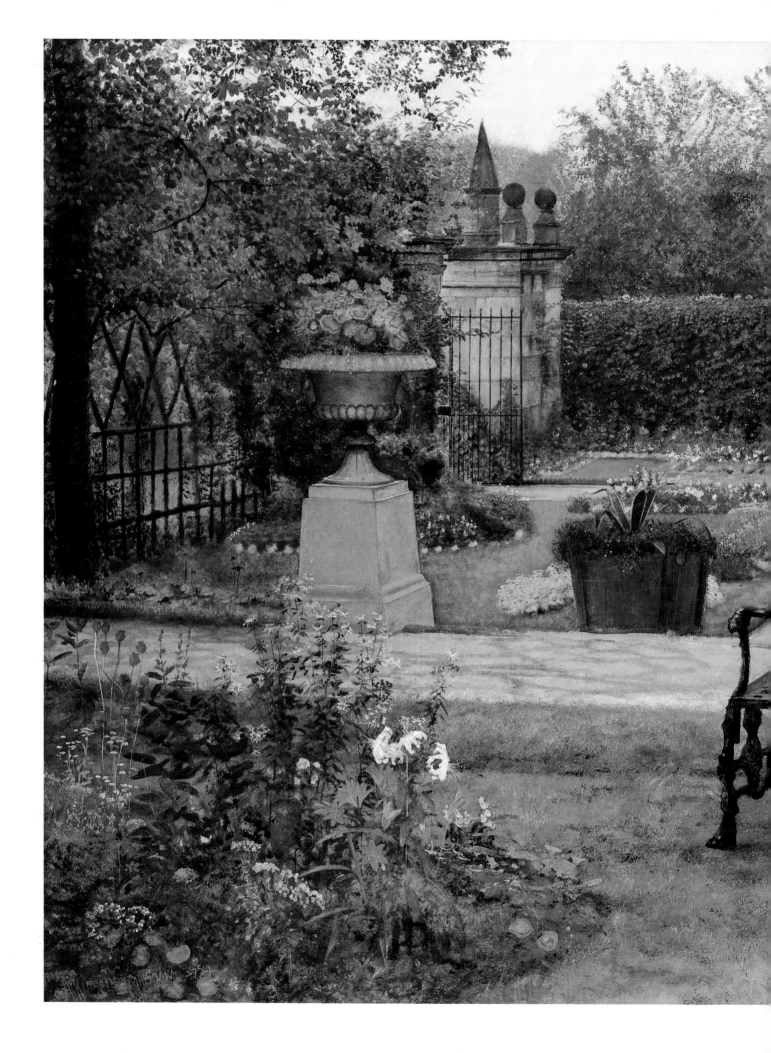

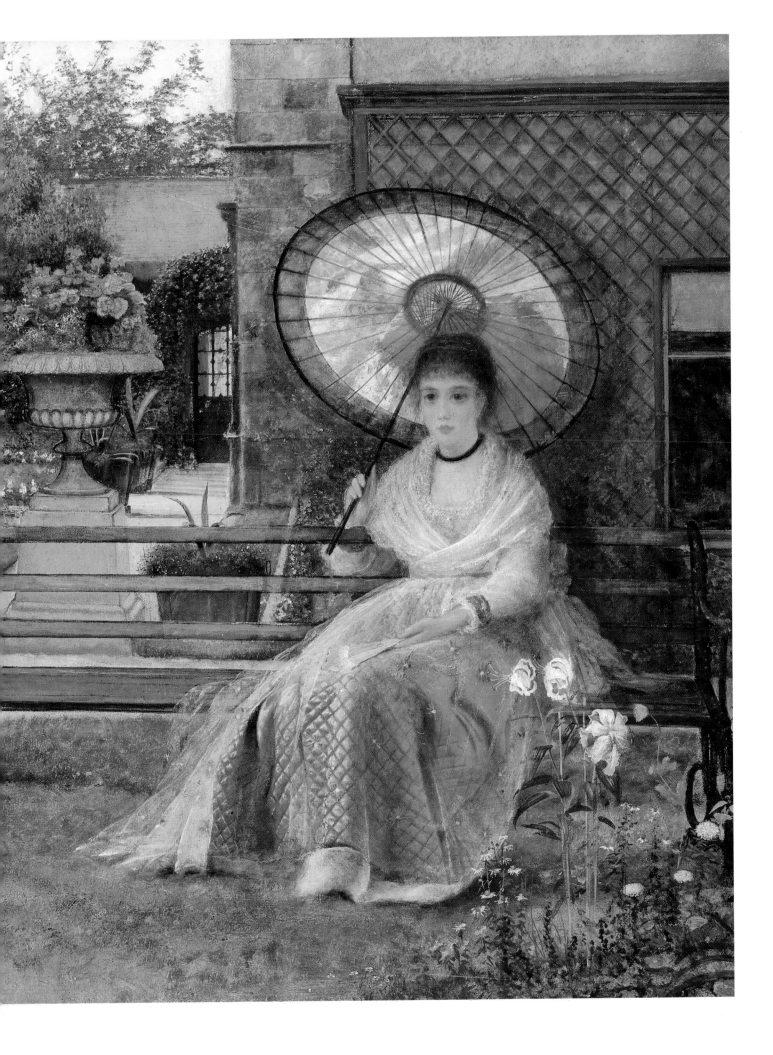

The success of the Tissot-inspired figure pictures may have been the stimulus for Grimshaw to tackle the formula of another successful contemporary artist, the recreated classical world of Lawrence Alma-Tadema, whose reconstructions of life in Greece and Rome were extremely popular in the last quarter of the nineteenth century. His paintings purport to show the domestic scenes and social manners of the ancients—though they appear to differ very little from those of contemporary Victorian England. One great Empire could look back to another and see men and women faced with the same problems and decisions. Alma-Tadema humanized the society of ancient Rome and succeeded in presenting a brightly-lit, colourful world as a form of escapism from the dirt of nineteenth-century industrial life. His painting technique, with its skilful imitation of veined marble and tessellated pavements, was a source of delight to the contemporaries who bought his smart pictures.

Leeds occasionally saw his work: at Hassé's in 1872 *The Vintage Festival* was shown; in 1875 *In the Temple* and *Grecian Archway* were seen at the *Yorkshire Exhibition of Arts and Manufactures*, and Grimshaw could easily have seen other paintings in London. His pastiches of Alma-Tadema were not always convincing, yet paintings such as *Luxury*, *Lady in an Exotic Interior*, *Golden Visions*, *At Lesbia's*, *An Ode to Summer* and the presently unlocated *Before the Floralia* were produced for the art market over a number of years. The most successful Grimshaw picture of this genre is certainly *Two Thousand Years Ago* (Pls. 41, 47), which is clearly based on Alma-Tadema's picture *Pleading* (Pl. 42). Here Grimshaw's figures (often a problem for him, with his lack of professional training) are convincingly worked out, as is the overall detail, bathed in the brilliant light that gives the painting its feeling of airiness. In another picture, *Fiamella* (Pl. 43), Grimshaw paints a girl who would have been quite at home in St John's Wood; and indeed there is here more than a hint of the new 'aesthetic' woman.

Of more longstanding importance to Grimshaw than ancient Rome was the

45. *Iris*. 1886. Oil on canvas, 81.5 × 122.2 cm (32⅛ × 48⅛ in). Leeds City Art Galleries

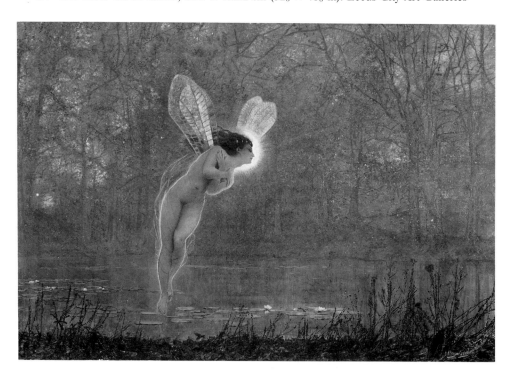

appeal of the literary heroes and heroines to be found in Longfellow's and Tennyson's poetry; moreover, many of the titles of his paintings are quotations from Wordsworth, Shelley and Browning. He named five of his children after characters in Tennyson's *Idylls of the King*: Gertrude, Enid, Arthur, Lancelot and Elaine. For them Knostrop must have seemed a happy Camelot, a real castle of enchanted dreams.

A series of paintings based largely on subjects from recent or contemporary literature was undertaken from the 1870s: *The Beleaguered City* (after Longfellow), *The Lady of Shalott* (after Tennyson), a series of nymphs called *Dame Autumn* or *Iris*, and Diana the huntress hovering in the air above *Endymion on Mount Latmus* (after Keats and Longfellow); direct from ancient myth Grimshaw was to paint *Ariadne* and *Medea*. One of the strangest of these paintings is *Elaine* (Pl. 56), which follows a text from Tennyson's *Idylls of the King*. Grimshaw gives us 'the dumb old servitor, on deck, / winking his eyes and twisted all his face'. Elaine herself is shown, 'In her right hand the lily, in her left / The letter—all her bright hair streaming down'. The poem was illustrated by Gustave Doré in the Moxon edition of 1877, and certain similarities between Grimshaw's painting and the published engraving can be seen. Such a painting of Tennysonian romance embodies through the heroine, Elaine, feelings of devotion and sacrifice.

Another picture, *Iris*, of which there are several versions, was, in 1886, Grimshaw's last exhibited work at the Royal Academy (Pl. 45). Iris was a messenger of the gods, sent to wither flowers in autumn; she stopped to admire the water lilies and was turned into a rainbow for her disobedience. Personifications of the seasons were popular subjects with artists at the time; Leighton's *Persephone* (symbol of spring), now at Leeds City Art Gallery, is one of the peaks of the Victorian High Renaissance.

Grimshaw's subjects from literature and classical mythology were certainly successful and found a ready market. The paintings feature death, revenge, abandonment, disobedience and transformation, and can be seen as personifying some of the themes that fascinated writers of the Victorian period. All the paintings have a solitary female figure as the main protagonist and again reflect the anomalous place of woman in contemporary society (cf. *Meditation*, Pl. 35).

When Grimshaw accepted an invitation to exhibit at Sir Coutts Lindsay's Grosvenor Gallery in 1885, he could be said to have allied himself with the more progressive elements in the art world. The painting shown was called *A Vestal*, probably a mixture of the neo-classical and St John's Wood 'aesthetic'. The Grosvenor Gallery was seen as promoting those who pursued an 'art for art's sake' line which in some quarters was considered unhealthy. The famous battle artist, Lady Butler, writing in her diary in 1879, explained how she came to begin her great painting *Scotland for Ever!*:

[It] was born in a moment of exasperation at the Greenery
Yallery of Sir Coutts Lindsay's Grosvenor Gallery. The
Grosvenor was the home of the 'Aesthetes' of the period, whose
sometimes unwholesome productions preceded those of our
modern 'Impressionists'. I felt myself getting more and more
annoyed while perambulating these rooms, and to such a point
of exasperation was I impelled that I fairly fled, and breathing
the honest air of Bond Street, took a hansom to my studio.
There I pinned a 7-foot sheet of brown paper on an old canvas
and, with a piece of charcoal and a piece of white chalk, flung
the charge of 'The Greys' upon it.

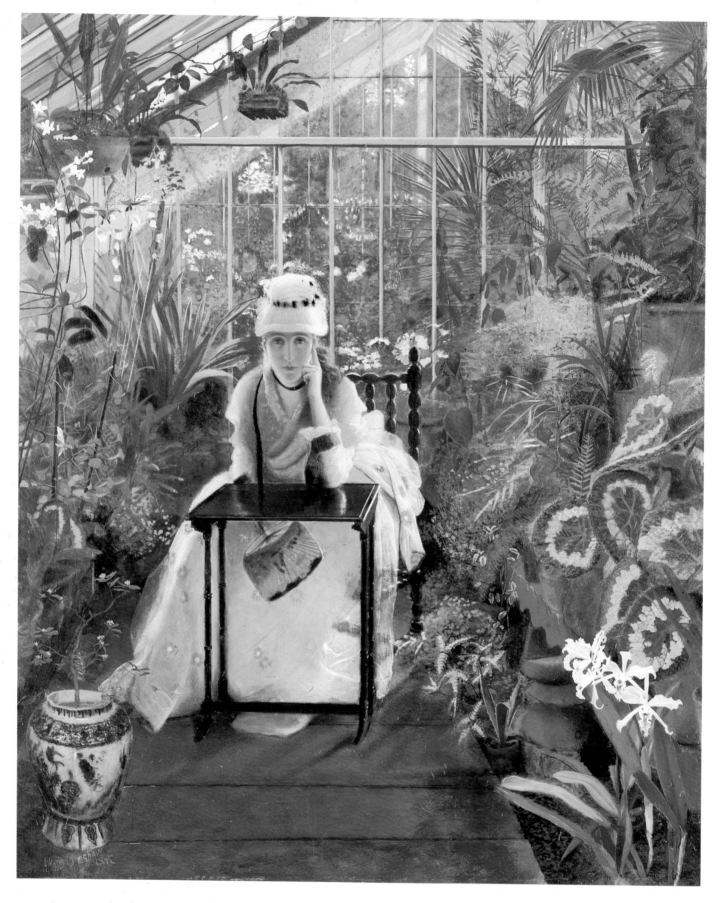

46. *Il Penseroso*. 1875. Oil on canvas, 59.7 × 49.5 cm (23½ × 19½ in). Private collection

47. Detail of *Two Thousand Years Ago* (Plate 41)

That the new taste for symbolist subjects by Burne-Jones, and the 'pure' art of J. McNeill Whistler should not have been to Lady Butler's taste is not surprising. Nor was it to the liking of Ruskin whose famous remark concerning Whistler's *The Falling Rocket* ('flinging a pot of paint in the public's face') led to the libel suit which bankrupted Whistler and eclipsed the reputation of the increasingly unstable critic.

During the second half of the 1870s Grimshaw rented a house in Scarborough which he called 'Castle-by-the-Sea' after Longfellow's poem. Following the death of three children at Knostrop and with Mrs Grimshaw pregnant again, a second home at the seaside seemed a sensible move. There the twins Lancelot and Elaine were born, in the town which Grimshaw was to paint so often.

When Grimshaw took over Castle-by-the-Sea it was to be a place of entertainment, just as Knostrop Hall was in Leeds; according to his daughter Enid's recollections, George du Maurier, Ellen Terry and J. L. Toole were all guests there. In 1931 Enid wrote to the then owner of Castle-by-the-Sea with information about its history and the alterations made by her father: the installation of old woodwork, decorative tiling, sculptured panels by Boehm and the provision of a studio. The house is in Mulgrave Place and overlooks North Bay; its builder, and the occupant of 'The Towers' along the road, was Thomas Jarvis, a wealthy Scarborough brewer who was to be Grimshaw's chief local patron. They had met as early as 1874 when Grimshaw painted *The Old Gates, Yew Court, Scalby, near Scarborough* for him (Pl. 48).

By the 1870s Scarborough was entering upon a new phase of prosperity, independent of the fishing industry or the old spa facilities. From 1867 the South Bay was dominated by Cuthbert Brodrick's Grand Hotel, built on French lines, and then one of the largest hotels in England. Along from the hotel, the suspension bridge, opened in 1827, joined the Regency Crescent to the new Victorian development. At the other end of the bay lay the harbour, the old fishing town and the ruins of the castle.

Before ever settling in the town, Grimshaw had painted a view as early as

48. *The Old Gates, Yew Court, Scalby, near Scarborough.* 1874. Oil on paper on panel, 17.8 × 43.2 cm (7 × 17 in). Private collection

49. *'Sic Transit Gloria Mundi', The Burning of the Spa Saloon, Scarborough*. 1876. Oil on canvas, 82.5 × 122 cm (32½ × 48 in). Scarborough Art Gallery

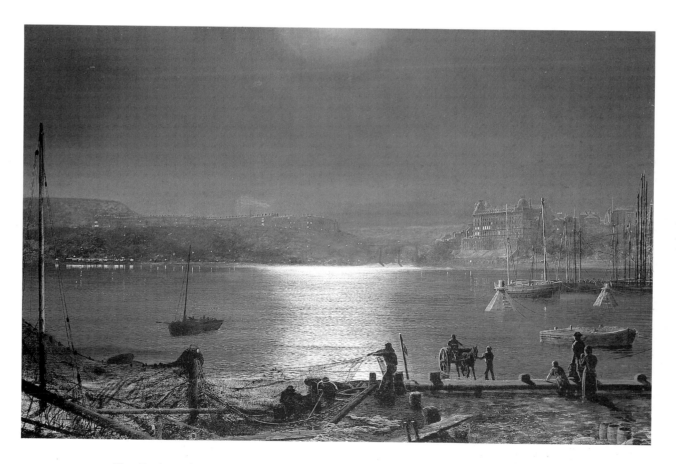

50. *Scarborough Bay*. 1871. Oil on canvas, 60.4 × 90.2 cm (23¾ × 35½ in). Private collection

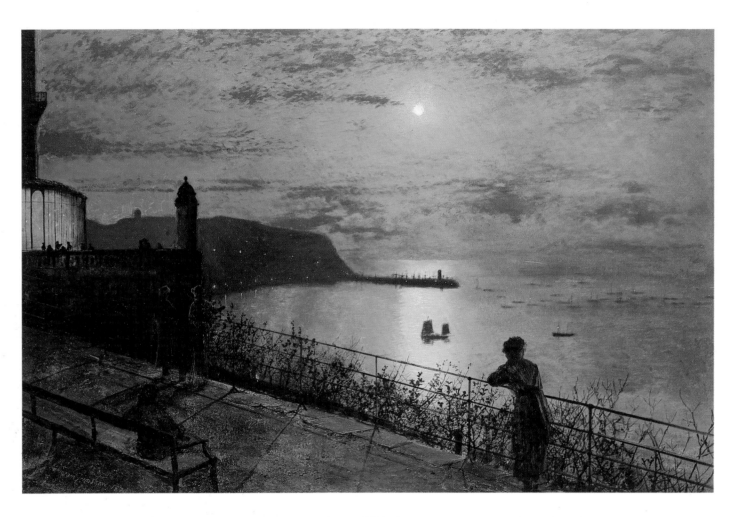

51. *Scarborough from Seats near the Grand Hotel*. 1878. Oil on canvas, 50.8 × 76.2 cm (20 × 30 in).
Private collection

52. Detail of *Scarborough Bay* (Plate 50)

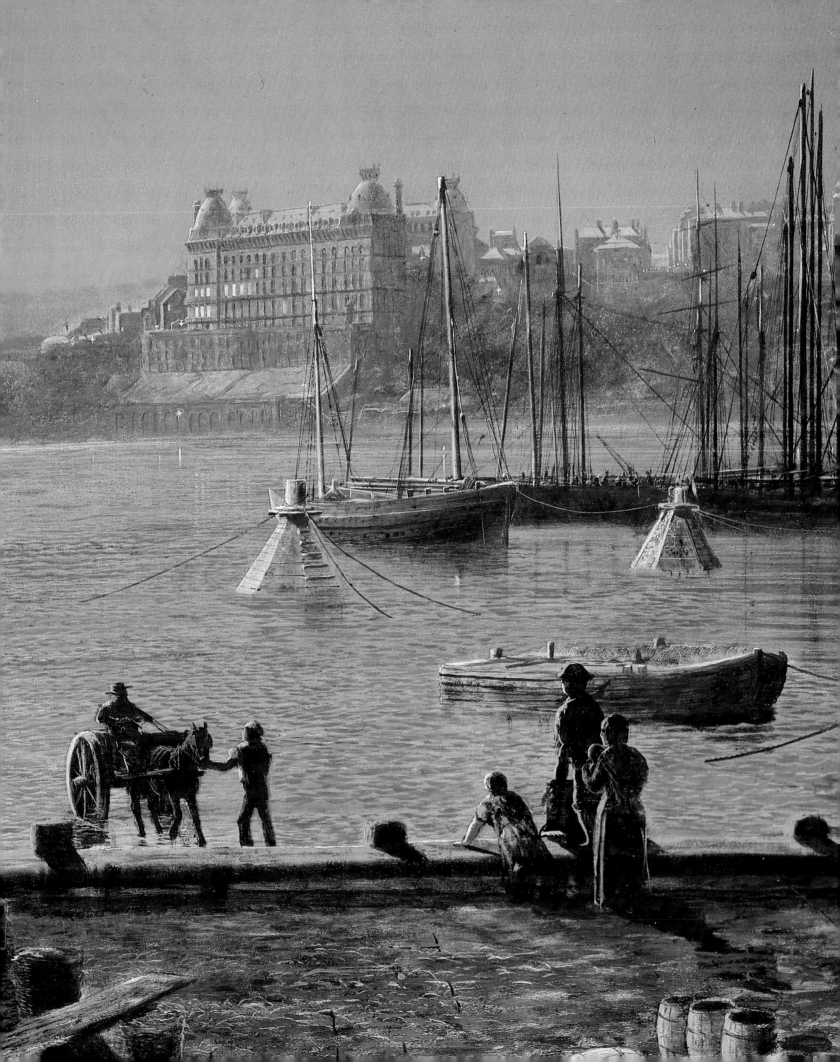

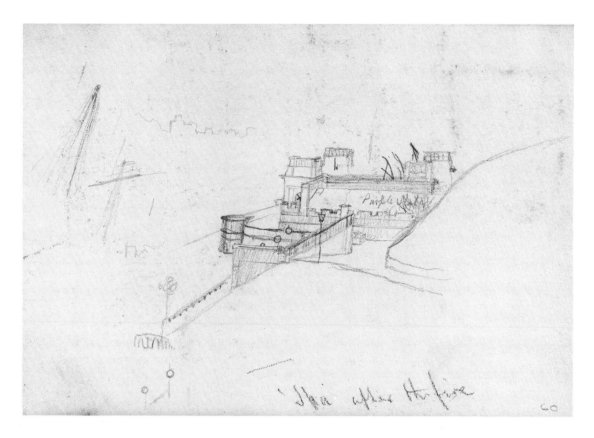

53. *Spa after the Fire*. 1876. Pencil, 12.2 × 18.2 cm (4¾ × 7⅜ in). Leeds City Art Galleries

54. *A Street in Old Scarborough*. *c.*1877. Pencil, 12.2 × 18.2 cm (4¾ × 7⅜ in). Leeds City Art Galleries

1871. *Scarborough Bay* (Pls. 50, 52) is grand in scale, impressive in its lighting effects, and shows in the amount of activity taking place, one of the keys to the future concerns of Grimshaw's painting. The brilliance of this night scene, with fisher-folk landing the catch, is watched over by the massive new hotel, symbol of the new wealth of the industrial age. The guests on holiday are unaware of the essential night-time activity for those who still earned their living in the old ways.

Seven years later Grimshaw painted a view from the opposite direction, *Scarborough from Seats near the Grand Hotel* (Pl. 51). To those guests admiring the view, it is probably no more than picturesque, with the chance to watch the fishing fleet returning to port. Grimshaw combines these two kinds of activity, the watching and the working, in a composition which gives him an opportunity to portray different light effects, natural and man-made. Such paintings are the essence of Grimshaw, who presents to the spectator a scene of calm observation where the subject is given a poetic overlay by the use of light, usually moonlight.

However, on occasion, actual events did present an opportunity to introduce drama into the composition. Shortly after taking over Castle-by-the-Sea, the Grimshaw family witnessed the burning of the spa building, below the South Cliff. The Leeds sketchbook contains a summary study of the ruins, drawn the day after the event (Pl. 53); on this Grimshaw based his painting '*Sic Transit Gloria Mundi*', *The Burning of the Spa Saloon, Scarborough* (Pl. 49). In her 1931 correspondence Enid Grimshaw, referring to the picture, commented that it contained portraits of her mother, brother Arthur, and herself on the cliff path watching the fire. Equally dramatic is the series of paintings featuring a burning tar barrel which used to be lit by the harbour entrance to guide in the fishing boats returning during a storm.

In Peril (Pl. 57), with its related study (Pl. 55), shows Grimshaw using sketches for the background details. This painting is one of a series which began with *The Harbour Flare* and *Burning Off*, giving the opportunity to paint a fiery sky and dashing waves. In such paintings the wild spectacle of a stormy night brings to mind J. M. W. Turner's epic series of canvases showing the *Burning of the Houses of Parliament*, one version of which was then in the Leeds collection of John Marshall (and is now in Cleveland Museum of Art).

The Leeds sketchbook contains many direct studies of Scarborough streets and local characters around the old town. *A Street in Old Scarborough* (Pl. 59), with its

55. *In Peril. c.*1877–9. Pencil, 12.2 × 36.4 cm (4¾ × 14⅜ in). Leeds City Art Galleries

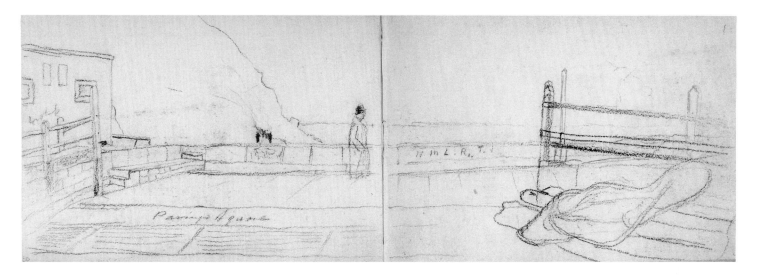

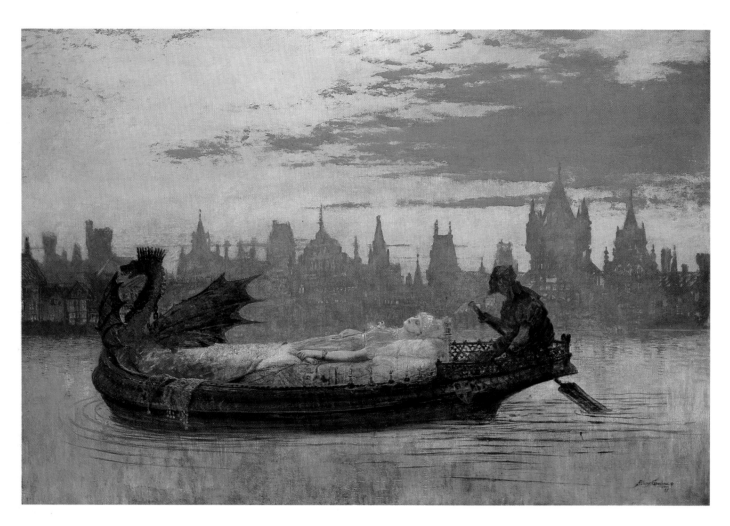

56. *Elaine*. 1877. Oil on canvas, 82.5 × 122 cm (32½ × 48 in). Private collection

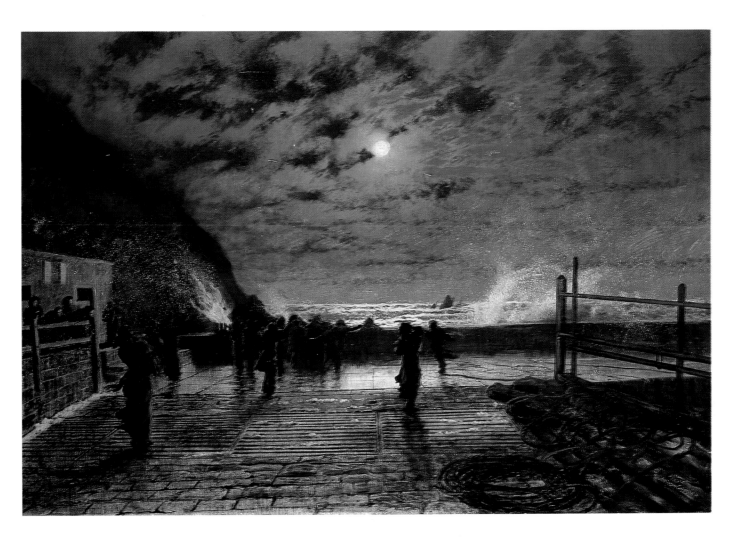

57. *In Peril*. 1879. Oil on canvas, 81.3 × 119.4 cm (32 × 47 in). Leeds City Art Galleries

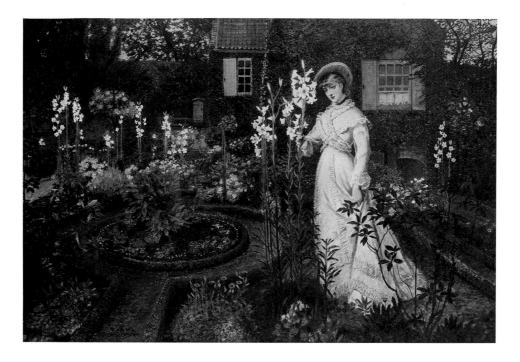

58. *The Rector's Garden: Queen of the Lilies.* 1877. Oil on canvas, 80 × 122 cm (31½ × 48 in).
Preston, Harris Museum and Art Gallery

related drawing (Pl. 54), brings Grimshaw close to that type of Victorian subject which harked back to the 'good old days' before industrialization.

On occasion Grimshaw would introduce a nostalgic touch into his street scenes which goes beyond mere 'staffage'. This feeling of romantic sentiment is nowhere more successfully achieved than in *Home Again* (see title page), set in the fishing port of Whitby. The theme of the 'return' was a popular one with Victorian artists. Often the character who has returned arrives too late, after a loved one's death; however, in Grimshaw's painting, the joy of a reunion is being celebrated. The picture's composition, with its alternating bands of dark and light masses, presents a soft background to the embracing couple. The forest of masts is reminiscent of early paintings by Whistler and his Thames etchings. Tissot had also featured dockland in his London series. *Home Again* is a rare instance in Grimshaw's art of the human side of fishing life, but one where he has used all his usual devices of light shining through fences and masts.

The Scarborough years were very successful ones for Grimshaw, providing as they did a unique subject in the town itself, which he explored and painted in great detail. In the nearby countryside he found other subjects to extend his range. He had already produced two versions of Yew Court, Scalby, and there in the garden he painted a young girl, seen admiring the flowers; the picture was entitled *The Rector's Garden: Queen of the Lilies* (Pl. 58). This is another kind of 'Home, Sweet Home', with the garden as a place of refuge and peace from daily cares. The figure herself may be a member of the owner's family, but a certain stiffness implies that her elegance may owe more to a fashion-plate engraving than to actual observation.

In contrast to life 'at home', Grimshaw transformed one of his most popular subjects, that of a lane with a lonely figure, into an evening scene with a farmer returning from the fields. *Forge Valley, near Scarborough* (Pl. 60) is one of Grimshaw's most successful creations, of which there are several versions. Here the scene is saturated in moonlight, with finely observed detail in the road tracks and shadows. At

his best Grimshaw never loses his ability to refine these touches. Such a simple scene does embody the artist's recurrent theme of toil, but instead of dwelling on this, the subject is subsumed into an overall poetic mood.

Quite suddenly, just when all seemed to be going so well, Grimshaw is reputed to have faced a financial crisis. Just what this was has never been discovered. It is said that he backed a bill for a friend who decamped, leaving him to pay the debt. Whatever the cause, the house at Scarborough, the coach, horses and groom had to be given up. For Grimshaw, this blow meant a return to Knostrop and the need to review his career and diversify his subject matter.

59. *A Street in Old Scarborough*. 1877. Oil on board laid on panel, 42 × 26.7 cm (16½ × 10½ in).
Private collection

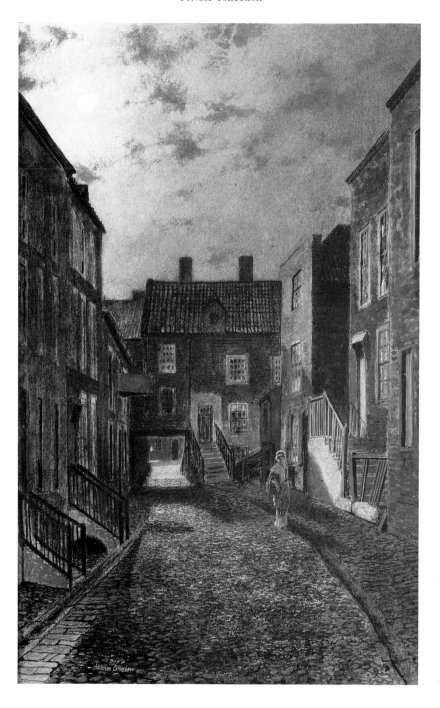

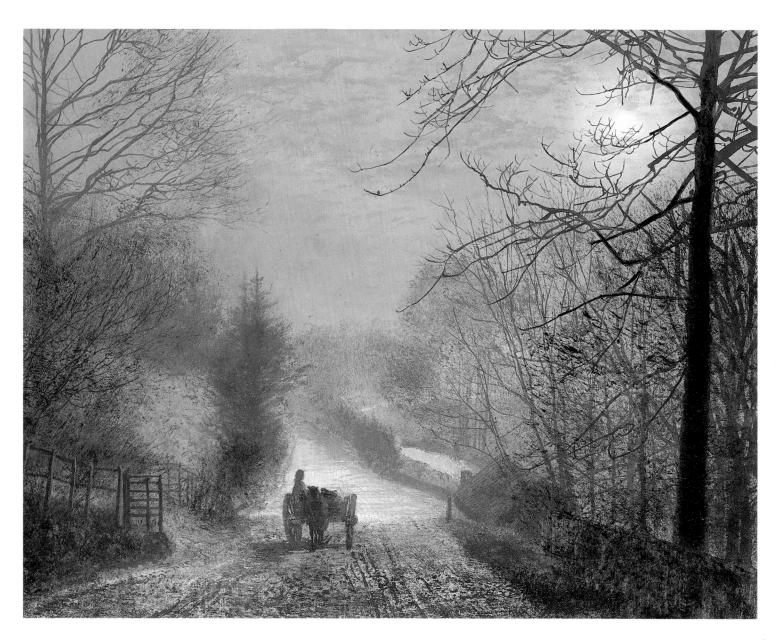

60. *Forge Valley, near Scarborough.* 1875. Oil on board, 44 × 54 cm (17 × 22 in). Private collection

PAINTER OF MOONLIGHT

After the artist's return to Leeds from Scarborough, there does seem to have been a need to increase his output, either to meet a greater demand, or to help pay for the disaster which had overtaken the family. Whatever the reason, in some years of the early 1880s over fifty dated paintings were produced. The inscription on the back of *Dulce Domum*, 'LABOR OMNIA VINCIT' (work conquers all), might well reflect this necessary increase. If so, Grimshaw may have felt the need to look for new subjects after 1880, and so came up with paintings of the Thames, urban centres and an expanded output of dock scenes.

Most of these new works were night scenes, enabling Grimshaw to present a subject familiar enough by day, but at night transformed into a place of mystery, even poetry. His increasing output of London subjects, and presumably their ready sale, led him in the mid-1880s to take a London studio, in Manresa Road, Chelsea, where family tradition relates his friendship with Whistler who, like Grimshaw, felt closely drawn to night-time effects.

To some extent Grimshaw's over-production of dock scenes has harmed his reputation. The paint quality can often seem perfunctory, with poor detail, thin, 'scratchy' paintwork, mechanically applied rigging, and buildings too obviously based on ruled perspective lines. Yet, in what one might see as the prototype for this kind of subject, all Grimshaw's care is evident. *Liverpool from Wapping*, c.1875 (Pl. 64), with its uncanny feeling for atmosphere, makes many of his other dock scenes seem contrived in comparison. The picture's quality comes from Grimshaw's care over his handling of paint. There is no hint of mechanical ruling. The rigging has a rich, smudgy feel, where lines sink into the background surface. The skyline and distance are hazy with enveloping gloom, even the mud on the road is painted with care so that it catches the light from the lamps and shop windows. The usual Grimshaw figures and carriages also seem fresh and spontaneous images. Here the artist has created a rare sense of place and time, a scene of modern life which yet has a quality of distance and mystery.

Although Liverpool remained Grimshaw's favourite location for his dockside views—another fine example is *Liverpool Quay by Moonlight* (Pl. 61)—he also painted scenes of Hull, Clydeside and even Gloucester. Works such as *Prince's Dock, Hull* (Pls. 62, 65) and *Shipping on the Clyde* (Pl. 63) have similar compositional elements, but otherwise they successfully vary the night-time theme. In a review of his painting *Salthouse Dock, Liverpool* at the Royal Academy in 1885, the *Art Journal* spoke favourably of the picture, saying that Grimshaw 'invests the subject with something akin to poetry'. It was well recognized by contemporaries that these views were not just topographical, but fitted in with the literary mood of the times, turning what was potentially squalid into art. *Baiting the Lines, Whitby* (Pl. 66) similarly shows a small fishing port that Grimshaw has transformed at night into a scene of mysterious activity.

From the year 1880 Grimshaw began to paint London and the Thames. The atmosphere in the capital was a particular attraction, with its dense fogs and river

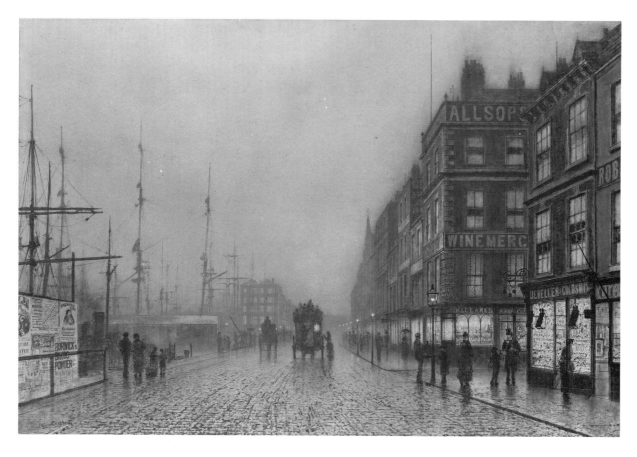

61. *Liverpool Quay by Moonlight*. 1887. Oil on canvas, 61 × 91.4 cm (24 × 36 in). London, the Tate Gallery

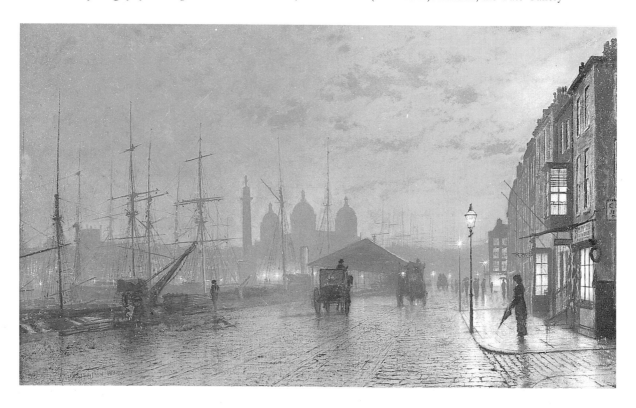

62. *Prince's Dock, Hull*. 1887. Oil on card, 30.5 × 49.5 cm (12 × 19½ in). Hull, Ferens Art Gallery

mists. Dickens presents a masterly description of London grime in the first chapter of *Bleak House*:

> Smoke lowering down from chimney-pots, making a soft black drizzle, with flakes of soot in it as big as full-grown snowflakes—gone into mourning, one might imagine for the death of the sun. . . . Fog everywhere. Fog up the river, where it flows among green aits and meadows; fog down the river, where it rolls defiled among the tiers of shipping, and the waterside pollutions of a great (and dirty) city. . . .

Foreigners often commented on the dirt of London, the mud, the fog, the wretched street urchins, drunken women and blatant street-walkers.

Grimshaw's paintings of the 1880s have a much greater breadth as he sought to accommodate the possibilities of river and city life. *Nightfall down the Thames* (Pls. 69, 70) is a quintessentially London view, inviting the spectator to follow the path of light to St Paul's Cathedral, with a perfect balance between blocks of light and shadow. Whistler is reputed to have said, 'I thought I had invented the Nocturne, until I saw Grimmy's moonlights'.

In London, Grimshaw produced many other paintings of urban and river life, observing the contemporary scene not just in the lanes of Wimbledon or Wandsworth, but right into the heart of the capital, with views of Piccadilly, Fleet Street, The Strand, Chelsea and Hampstead (Pl. 67). The extension of Grimshaw's powers and his ease of handling can be seen in paintings such as *The Thames by Moonlight with Southwark Bridge* (Pl. 68), which is certainly majestic in concept; and, sure of his effects, he indulged himself with a new use of glazes to emphasize shadows, resulting in a vibrant surface quality. Darkness and heavy shadows contrast with a night sky suffused with broken light flooding down on to the water.

63. *Shipping on the Clyde*. 1881. Oil on board, 30.5 × 50.8 cm (12 × 20 in). Private collection

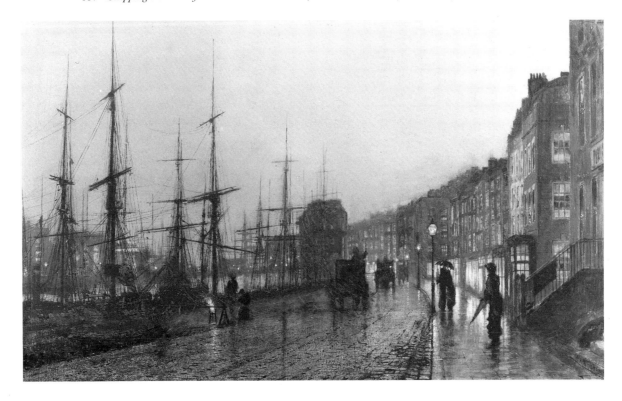

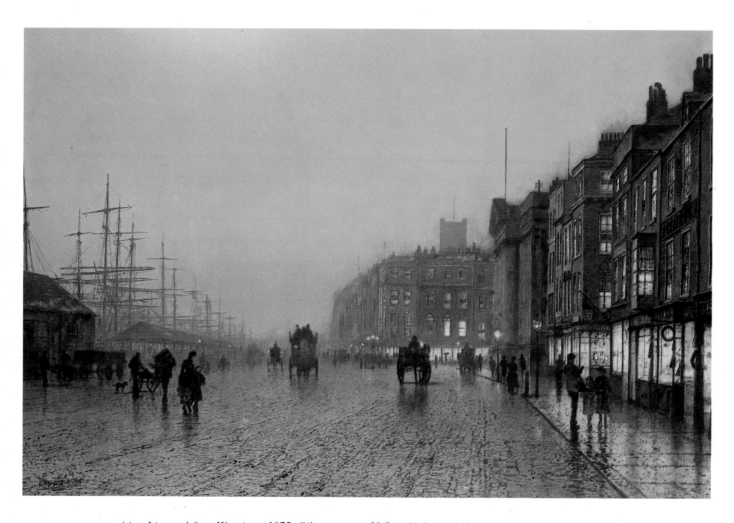

64. *Liverpool from Wapping. c.*1875. Oil on canvas, 59.7 × 88.9 cm (23½ × 35 in). Private collection

65. Detail of *Prince's Dock, Hull* (Plate 62)

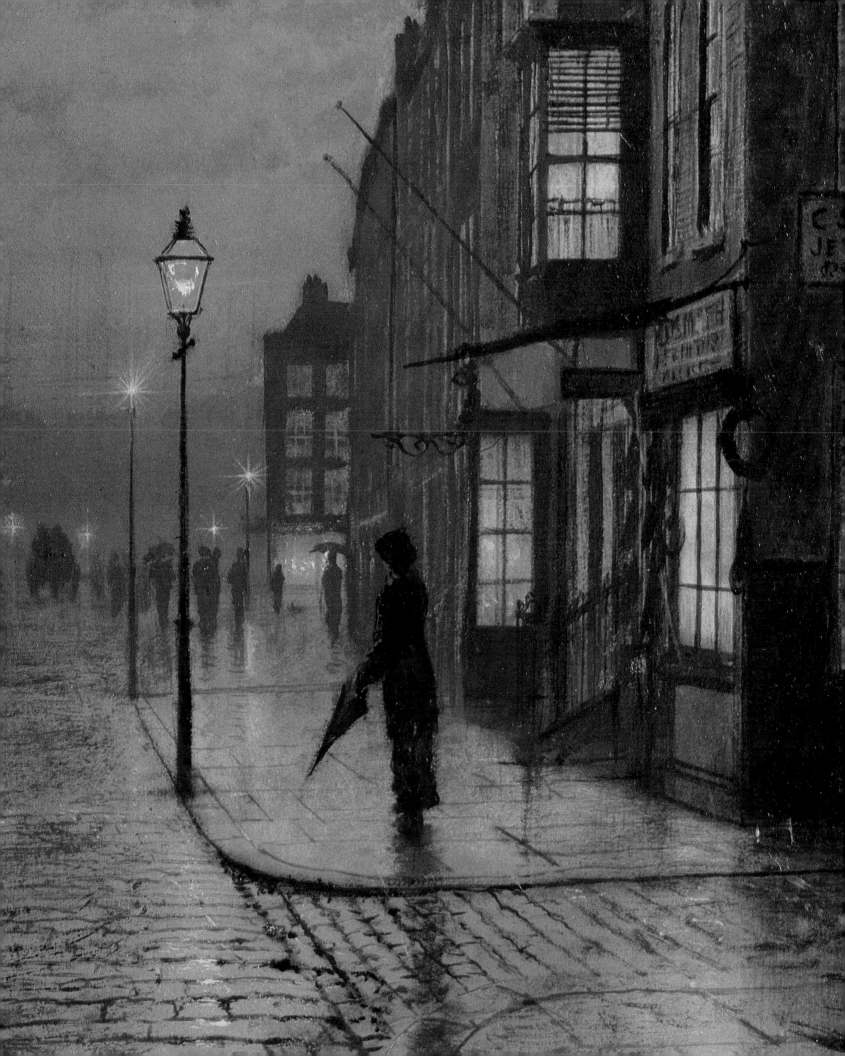

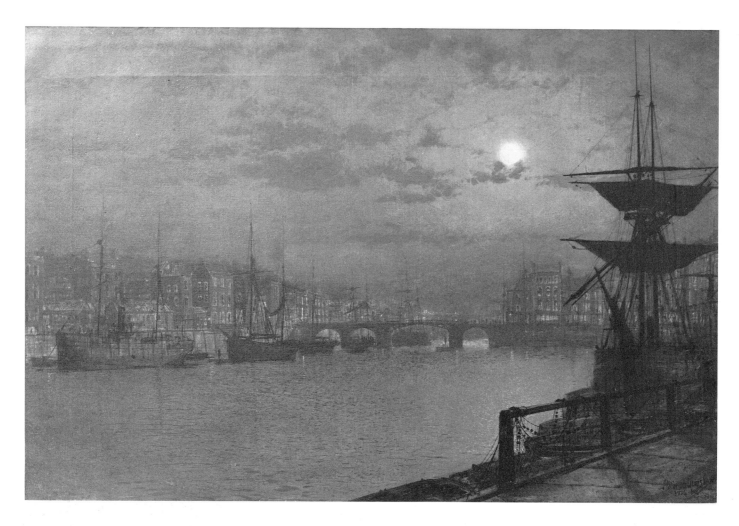

66. *Baiting the Lines, Whitby*. 1884. Oil on canvas, 50.6 × 76 cm (19$\frac{7}{8}$ × 29$\frac{7}{8}$ in). Wakefield Art
Gallery and Museums

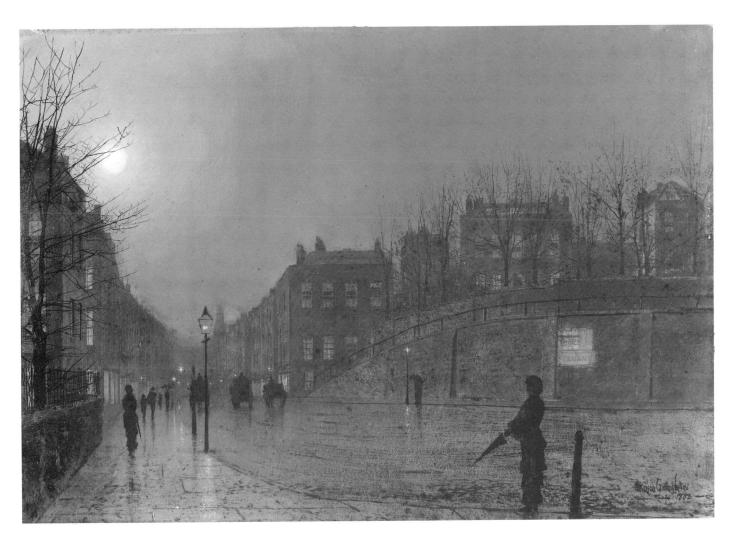

67. *View of Heath Street by Night*. 1882. Oil on board, 36.8 × 53.7 cm (14½ × 21⅛ in). London,
the Tate Gallery

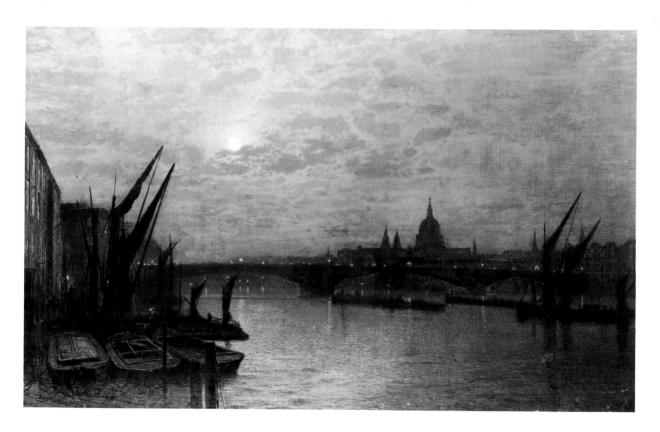

68. *The Thames by Moonlight with Southwark Bridge.* 1884. Oil on canvas, 75 × 127 cm (29½ × 50 in).
City of London, Guildhall Art Gallery

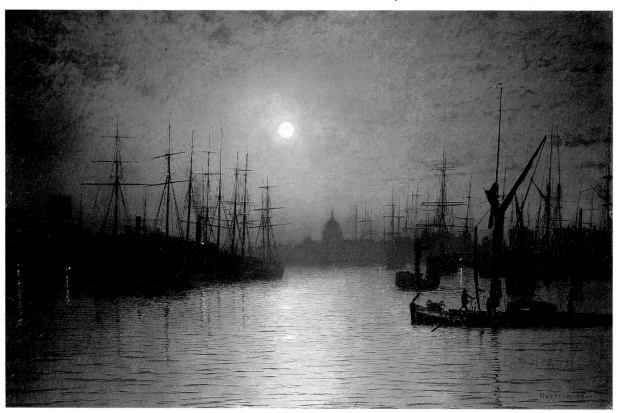

69, 70. *Nightfall down the Thames.* 1880. Oil on board, 40.2 × 63.1 cm (15⅞ × 24⅞ in). Leeds City Art Galleries

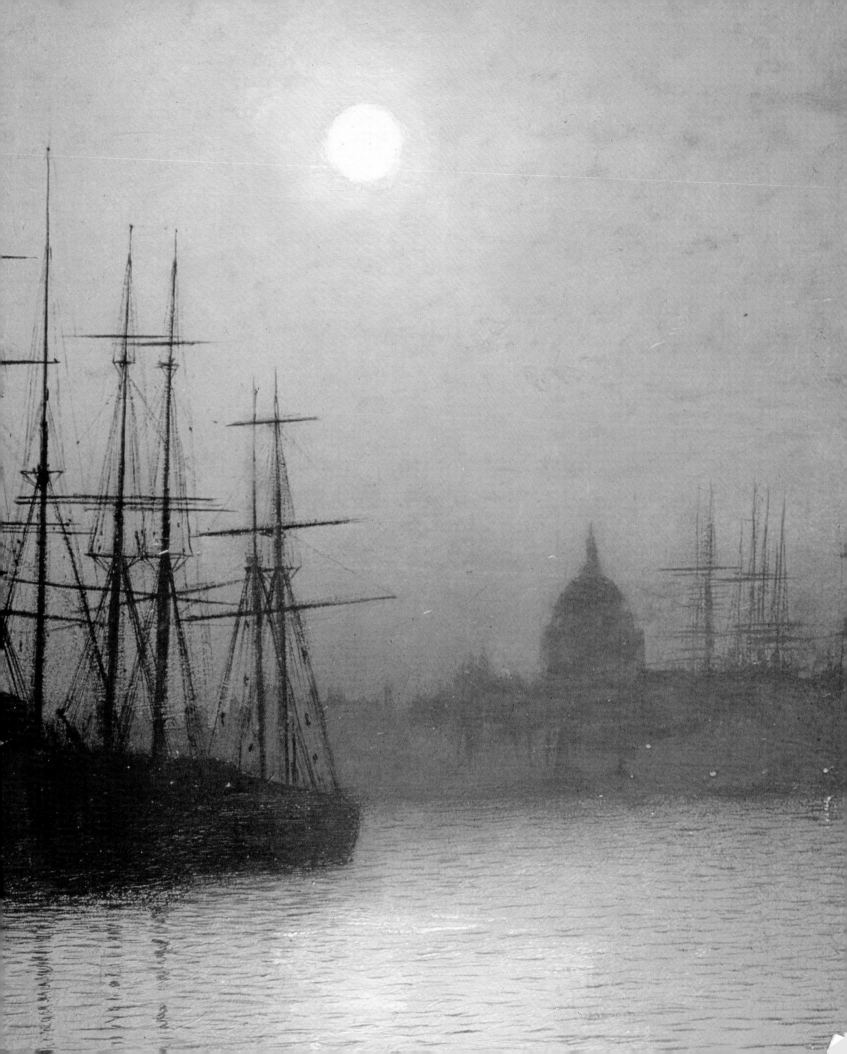

71. *The Houses of Parliament. c.*1880. Charcoal, 9 × 15.1 cm (3½ × 6 in). Leeds City
Art Galleries

As was the case earlier in his career, Grimshaw often produced drawings which he used as material for his oil paintings: *The Houses of Parliament* (Pl. 71) is one of his most finished studies. An oil painting related to this shows a side of Grimshaw in which he allows more of contemporary life to participate than was usual: *Reflections on the Thames: Westminster* (Pl. 72) presents a night-time scene which contrasts well the different strata of city life of the period. Here the composition takes the eye right round in a majestic sweep from the contemplative young lady looking at the river, to the Houses of Parliament along the embankment. The painting's title invites speculation, in line with Gissing's description of the city: 'London . . . a place of squalid mystery and terror, of the grimly grotesque, of labyrinthine obscurity and lurid fascination. . . .' and again, 'Murky, swarming, rotting London, a marvellous rendering of the impression received by any imaginative person who, in low spirits, has had occasion to wander about London's streets.' The play on the word 'reflections' in the painting's title is also a commentary on city life which contemporaries saw as inherently isolated. Grimshaw seldom made social comments, but here he has chosen to include a normal feature of such a location, the nightly rendezvous between street-walkers and clients. Such girls and their gentlemen customers occasionally appear on street corners in the many views of the dockside — a place where low life and respectable society could meet.

No such assignations occur on *Leeds Bridge* (Pl. 73), painted in the same year as the Westminster scene, and bought by Grimshaw's Leeds patron, Walter Battle. Whereas Thames river life was only hinted at, the Leeds painting shows all the bustle of a working inland port. The aspect is much the same today, save that the great warehouse on the left has been demolished, and river traffic no longer disturbs the quiet waters. In 1757 Dyer's poem *The Fleece* recorded this view on the Aire:

> And trade and business guide the living scene,
> Roll the full cars, adown the winding Aire
> Load the slow-sailing barges, pile the pack
> On the long tinkling train of slow-paced steeds.

Grimshaw presents us with the full animated picture, admirably caught on a sullen, grey day. In scale alone, he seems to be aiming for a new breadth, a grand city portrait of Victorian life.

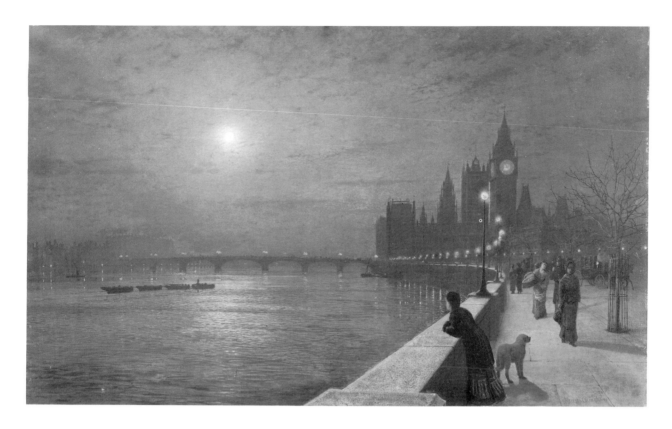

72. *Reflections on the Thames: Westminster.* 1880. Oil on canvas, 76.2 × 127 cm (30 × 50 in). Leeds City Art Galleries

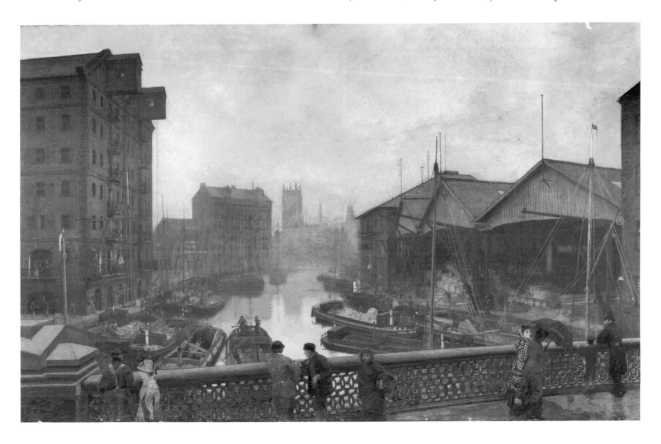

73. *Leeds Bridge.* 1880. Oil on canvas, 75 × 121.9 cm (29½ × 48 in). Leeds City Art Galleries

Two other views of Leeds show Grimshaw at his finest in conveying the mysteries of night-time in the town. *Park Row, Leeds* (Pl. 74) was commissioned by the directors of Beckett's Bank, seen on the right, to record their premises and the handsome street on which they stood. The *Leeds Mercury* found in it 'the same wonderful effects, the same grand gradations of tone, the same close attention to minuteness of detail, which most of his previous productions have displayed.' A similar notice might have been written about *Boar Lane, Leeds by Lamplight* (Pl. 81). This is one of Grimshaw's most lovingly painted street scenes, not only in the suggestion of night-time atmosphere, but also in the way the light from shop windows is reflected on the wet pavement and cobbles. The reality of the scene was probably unpleasant and muddy, but in Grimshaw's hands it is transformed into a mysterious wonderland. Mrs Gaskell describes this effect well in a passage in *Mary Barton*:

> It is a pretty sight to walk through a street with lighted shops;
> the gas is so brilliant, the display of goods so much more vividly
> shown than by day, and of all shops the druggists looks the most
> like the tales of our childhood, from Aladdin's garden of
> enchanted fruits to the charming Rosamund with her purple jar.

A year before producing his Westminster *Reflections*, Grimshaw had painted *Reflections on the Aire: On Strike* (Pl. 75), another example of his occasional social comment and again set at night. The view is a grim stretch along the river in Leeds, described thus by the *Yorkshire Post*:

> . . . some iron works at Hunslet seen from the North bank of
> the River Aire, between Leeds and Knostrop. The scene here
> when the furnaces are out of blast, is dismal and desolate in the
> extreme, and yet Mr Grimshaw chose it for pictorial illustration,
> partly, it would seem, for the chance it gave him of producing
> the iridescent effects of light which he knows how to manage so
> cleverly, and partly for the chance it gave him of suggesting a
> story. . . . The picture is Whistlerian in tone and conception, but
> it has more form and meaning and none of the eccentricity
> which one is accustomed to find in the nocturnes of the singular
> genius of Chelsea.

This painting was a forerunner of Grimshaw's more sombre canvases of the 1880s, and was in marked contrast to the brilliant light and colour of the Tissot-like domestic pictures.

Although Grimshaw is now primarily known for his moonlights, it is significant that most of his Royal Academy exhibits were figure paintings. Perhaps he saw these as fulfilling a desire to enter into the mainstream of Victorian art, yet one hundred years later it is the moonlight which characterizes his work and with which his name is synonymous.

Grimshaw's decision to broaden his early style and to exchange brilliant daylight for night effects, gave him the opportunity to evoke those feelings associated with darkness and moonlight. The new element in Grimshaw's painting, the sense of mystery and atmosphere seen in near empty streets or by foggy docksides, proclaimed their poetic, romantic qualities to contemporaries, as they do to us. The moon, breaking through clouds, casting a thousand shadows through a lace-work of branches, and picking out lonely houses glimpsed over high stone walls, reflects the atmosphere of many Victorian novels and poems; it is no wonder Grimshaw's

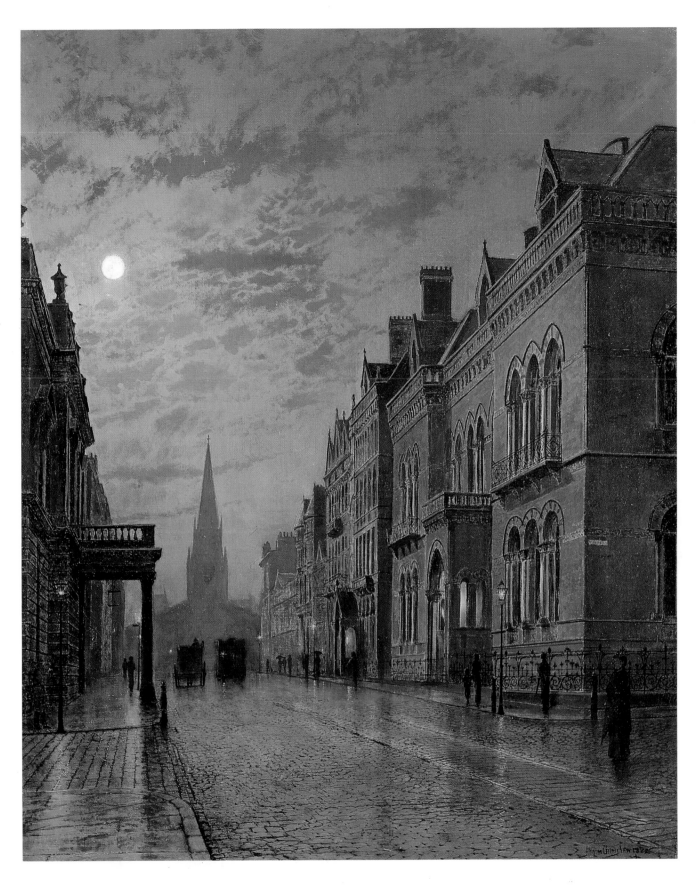

74. *Park Row, Leeds*. 1882. Oil on canvas, 76.2 × 63.5 cm (30 × 25 in). Leeds City Museums

paintings are in such demand for book illustrations. A few lines from Tennyson's *Enoch Arden* seem to demonstrate this most succinctly:

> The small house,
> The climbing street, the mill, the leafy lanes,
> The peacock-yewtree and the lonely Hall,
> The horse he drove, the boat he sold, the chill
> November dawns and dewy-glooming downs,
> The gentle shower, the smell of dying leaves. . . .

When he takes a line from a poem, Grimshaw gives us the *feel* of the words, the sense of time, the atmosphere—not merely an illustration of them.

For Grimshaw the same subject could be treated as a moonlight or a daylight scene, so that identical images are completely interchangeable. What might be called his 'suburban lane' theme is further developed when the artist focuses on the house itself (usually seen across an overgrown garden), and presents a portrait of a decaying mansion; in this we see the 'deserted house' type.

The newly built villas of England's Victorian cities, seen beyond high-walled lanes, certainly formed one of Grimshaw's most memorable creative images; by presenting them in moonlight he established a new genre. There were, of course, many precedents for other types of night scene: the riverscapes of the Dutch seventeenth-century painter, Aert van der Neer; the landscapes of Joseph Wright of Derby; the moonlights of the Pether family in the nineteenth century; and also paintings by Turner, forsaking the golden light of the sun, on occasion, to paint the moon.

75. *Reflections on the Aire: On Strike.* 1879. Oil on canvas, 81.2 × 121.9 cm (32 × 48 in). Private collection

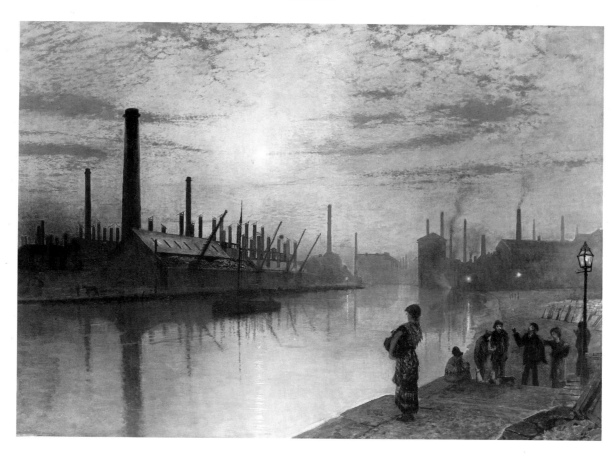

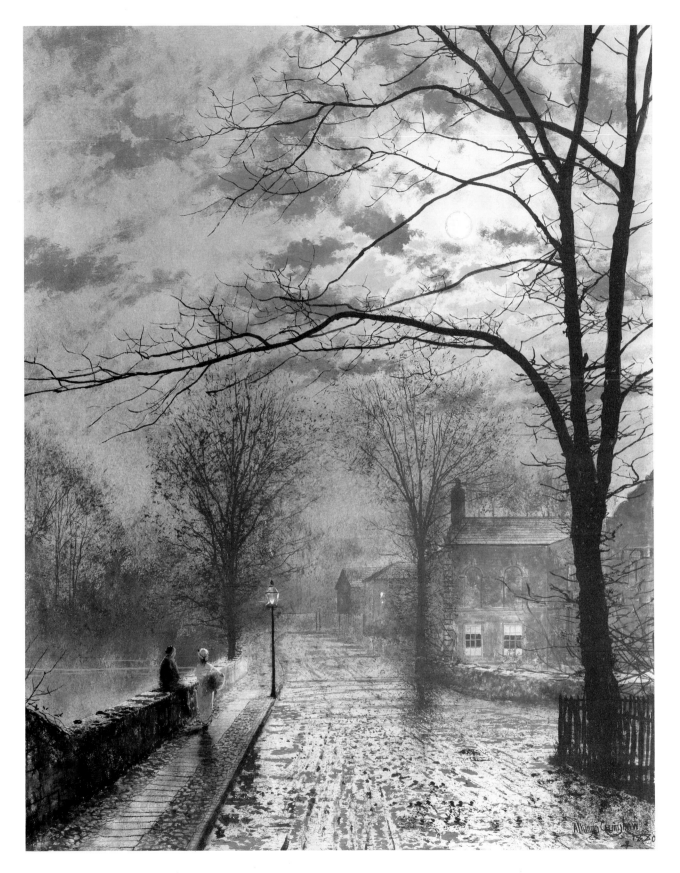

76. *A Lane by Moonlight with Two Figures*. 1880. Oil on board, 45.1 × 35.5 cm (17¾ × 14 in).
Collection of Mr Stanley Butterworth

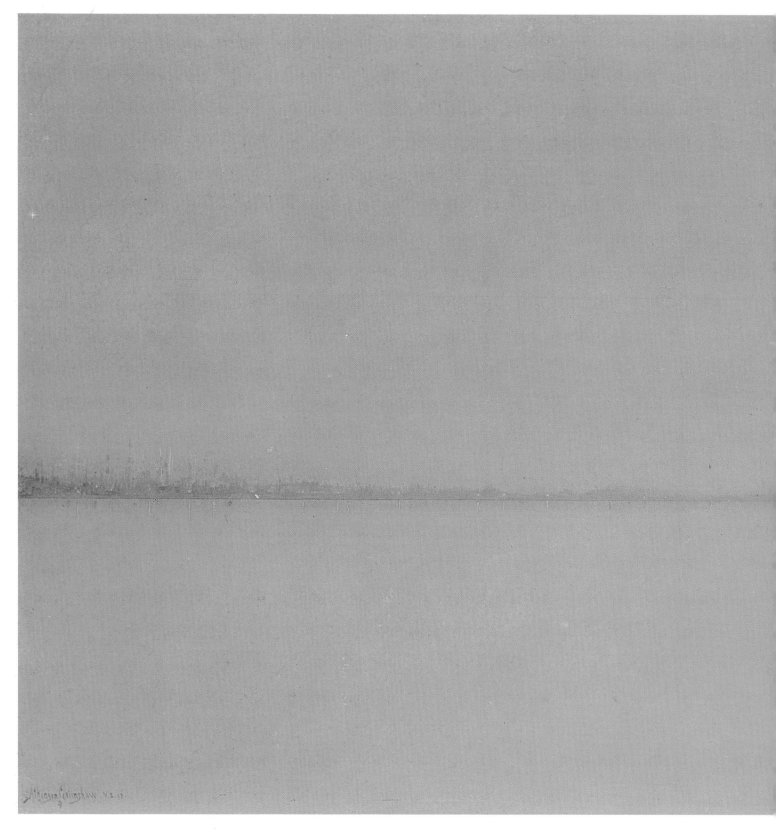

77. *At Anchor*. 1893. Oil on board, 23.5 × 47.6 cm (9¼ × 18¾ in). Private collection

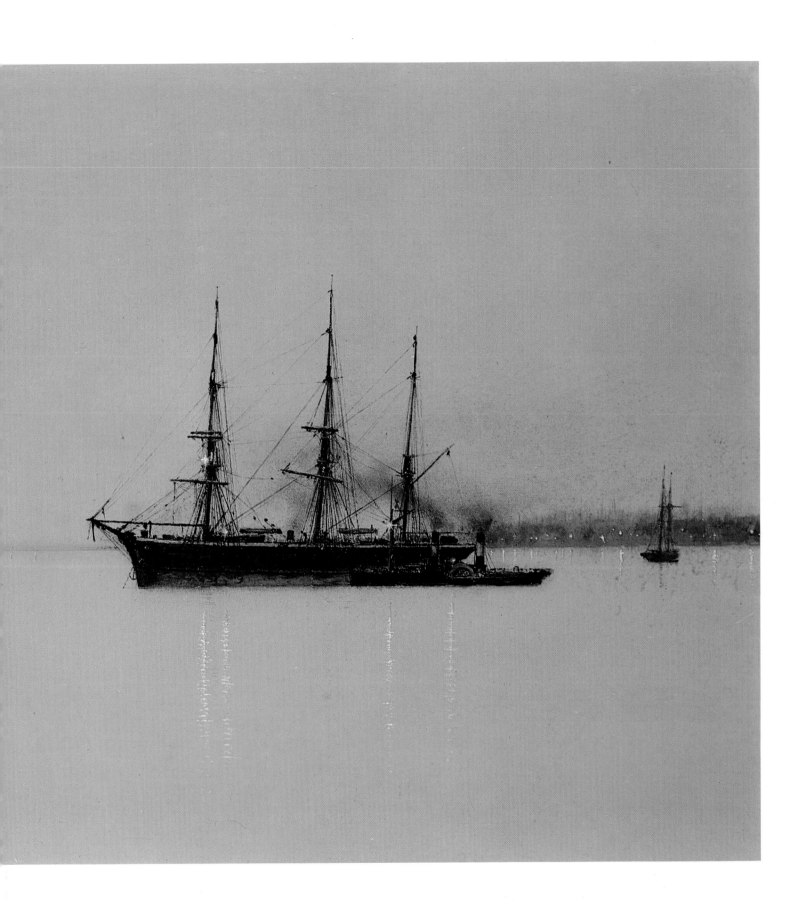

Contemporary literature provided Grimshaw with an abundance of texts relating to night: poems such as Wordsworth's *To the Moon*; Browning's *O Naked Moon Full-Orbed*; Tennyson's *Midnight*; and Shelley's *Night* are but four examples out of dozens. The city of Leeds itself, with its smoke pollution and frequent fogs, would also have provided atmospheric effects on which Grimshaw could draw. Usually he used the available subjects around him: that is, the streets of Leeds or London which he knew. By subtle variations he could produce strikingly different versions of virtually the same houses, or, occasionally, he would introduce a lake on one side of a street, as in *A Lane by Moonlight with Two Figures* (Pl. 76). He could also sharpen the detail and present a nostalgic twilight scene such as *Evening Glow* (Pl. 78).

When he wished to be more poetic, Grimshaw would present something grander, with suggestions of lovers meeting in secret, as in *Under the Moonbeams* (Pl. 79), a composition which he later used again, calling it *Far from the Madding Crowd*. Such paintings echo Tennysonian feelings about love: a night-time's longing, 'Half the night I waste in sighs' (*Maud*), or clandestine meetings, as of Leolin and Edith in *Aylmer's Fields*:

> Yet once by night again the lovers met,
> A perilous meeting under the tall pines
> That darken'd all the northward of the Hall.

The spirit of the age which Tennyson at times embodied, is carried over into Grimshaw's paintings in the common symbol of the moon. In *Enoch Arden* the moon

78. *Evening Glow. c.*1884. Oil on canvas, 28.5 × 43 cm (11¼ × 17 in). New Haven, Connecticut, Yale Center for British Art

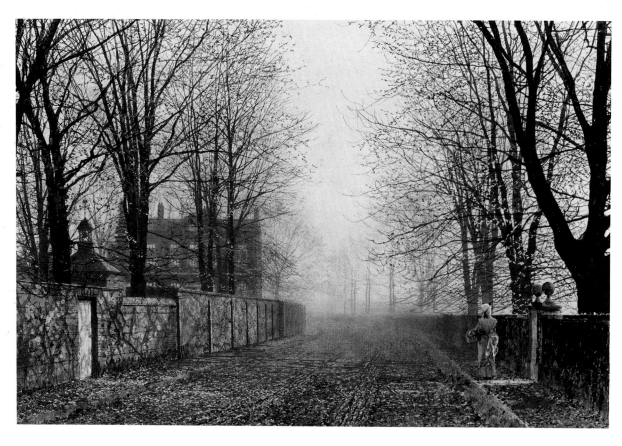

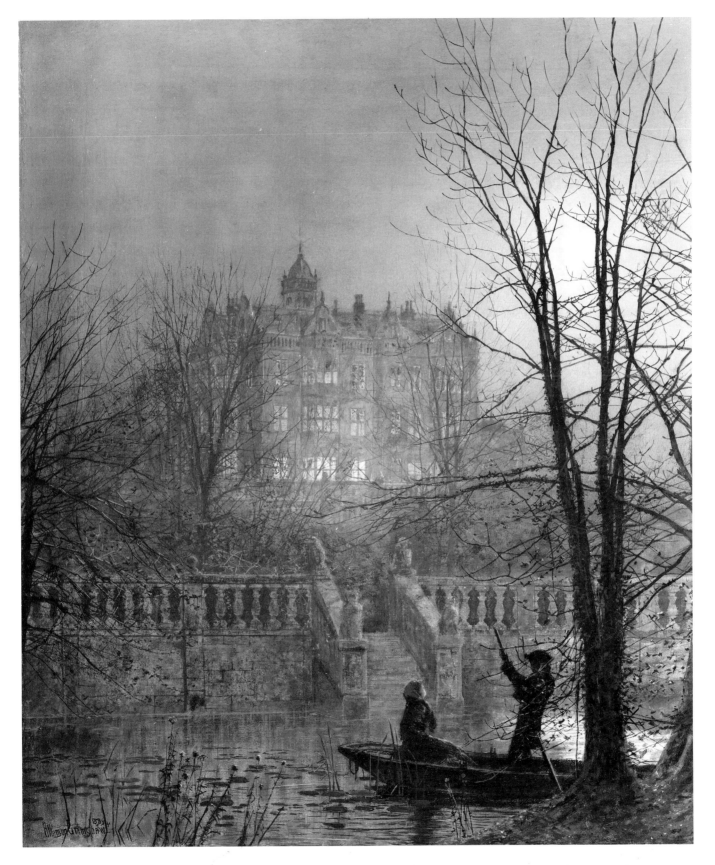

79. *Under the Moonbeams*. 1882. Oil on canvas, 75 × 62.2 cm (29½ × 24½ in). Collection of
Mr Harry C. Hagerty, Jr.

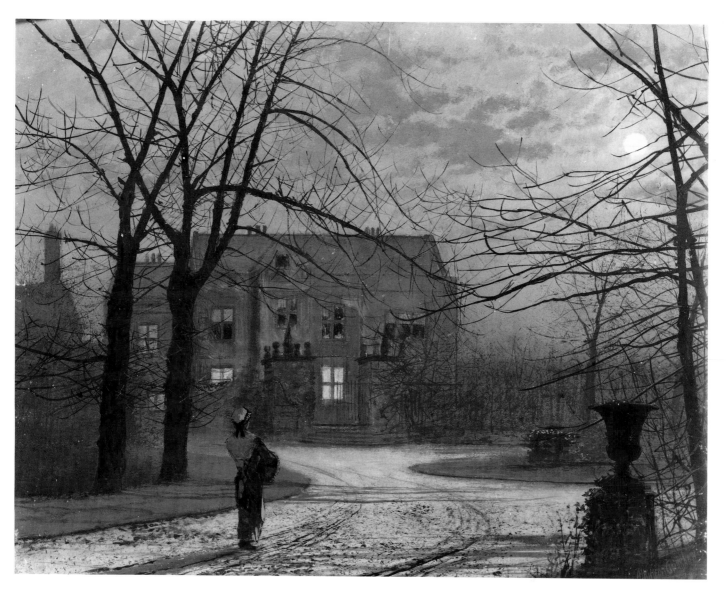

80. *Knostrop Hall, Leeds*. 1882. Oil on board, 34.3 × 43.2 cm (13½ × 17 in). Private collection

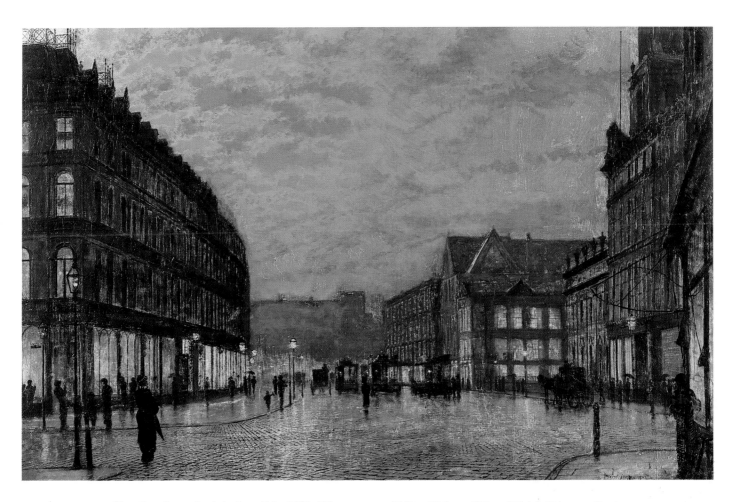

81. *Boar Lane, Leeds by Lamplight*. 1881. Oil on canvas, 48.9 × 76.8 cm (19¼ × 30¼ in). Private collection

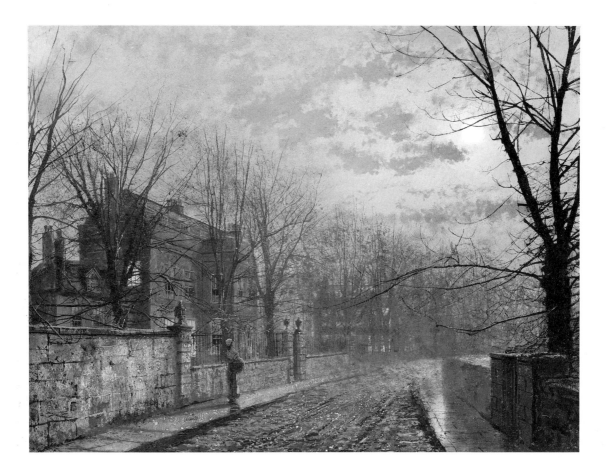

82. *St Anne's Lane, Headingley. c.*1880–5. Oil on board, 35.5 × 45.7 cm (14 × 18 in). Collection of Mr Harry Patterson

is the witness of sorrow; in *In Memoriam* moonlight has a healing power for those in grief:

> When on my bed the moonlight falls,
> I know that in thy place of rest
> By that broad water of the west
> There comes a glory on the walls. . .

These resonances touched Grimshaw's public also. His moonlights, as well as suggesting the strange beauty of night, of cities and lanes transformed by another light, also mask, with their atmospheric effect, the unpleasant side of industrialization. Grimshaw made commercial life acceptable by giving contemporary reality a romantic sheen; his moonlight paintings could be seen as an antidote to materialism. They were not 'high art', but preserved for the spectator an apparently timeless quality—hence the titles of many pictures, such as *Two Hundred Years Ago* or *Sixty Years Ago* (Pl. 85) which, in fact, when painted, recorded the contemporary scene. Grimshaw's paintings were, therefore, a reassuring statement about contemporary images; in a period of great change they presented a wistful nostalgia for the past.

Considering the great numbers of Grimshaw's existing paintings of suburban lanes, the market would appear to have been insatiable. *Sixty Years Ago*, which is in fact a daylight scene, is probably the largest painting of this type. It has magnificent texture and painted detail, with its water-filled puddles along the muddy road. The tree branches and fencing have a fine delicacy of touch. The young lady walking

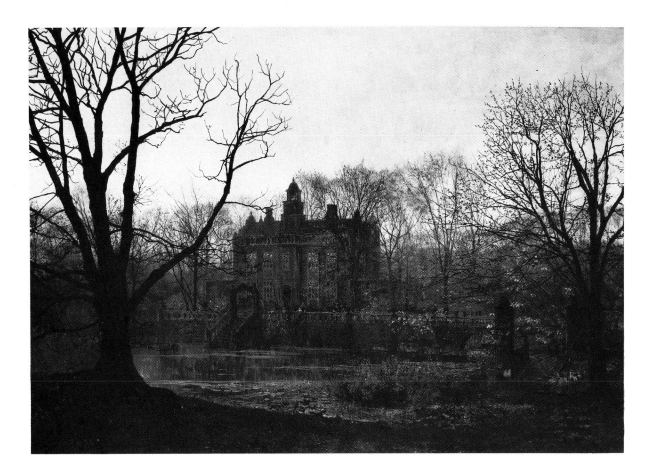

83. *A Yorkshire Home*. 1878. Oil on canvas, 81.3 × 122 cm (32 × 48 in). Harrogate Museums and Art Gallery

along, is not just a stock 'type', but is fashionably dressed down to her elegant lace gloves.

We know from the catalogue of the Knostrop Hall sale, which took place after the artist's death, that Grimshaw owned a copy of Robinson's architectural work *Vitruvius Britannicus* of 1833 on the subject of Hardwick Hall. For Grimshaw, living in a real Jacobean manor house, it would seem that past and present were equally real; just as myth and legend were to be plundered for subjects, so actual and historical houses could be put together to form an archetypal mansion. He did once paint Knostrop as it actually was (Pl. 80), familiar to us by the very recognizable gateposts, yet the fact that he often wrote his address 'Knostrop Hall' on the back of his paintings has led to the mistaken belief that many of his painted mansions are views of his own home.

St Anne's Lane, Headingley (Pl. 82) is an actual street in Leeds, but it is the exception. Most of Grimshaw's suburban lanes tantalize the spectator by looking very familiar and yet are quite unidentifiable. What was so special about a lonely old hall which appealed to nineteenth-century taste is difficult to explain. *A Yorkshire Home* (Pl. 83) belongs to the 'deserted house' type where nature is reasserting control over a man-made place. Again Tennyson often conveyed this sense of creeping decay, of the futility and ultimate pointlessness of life, particularly in his poem *Locksley Hall Sixty Years After*.

Of his suburban-lane subjects Grimshaw continued to produce excellent versions right up to the end of his life, though his later preference seemed to be for

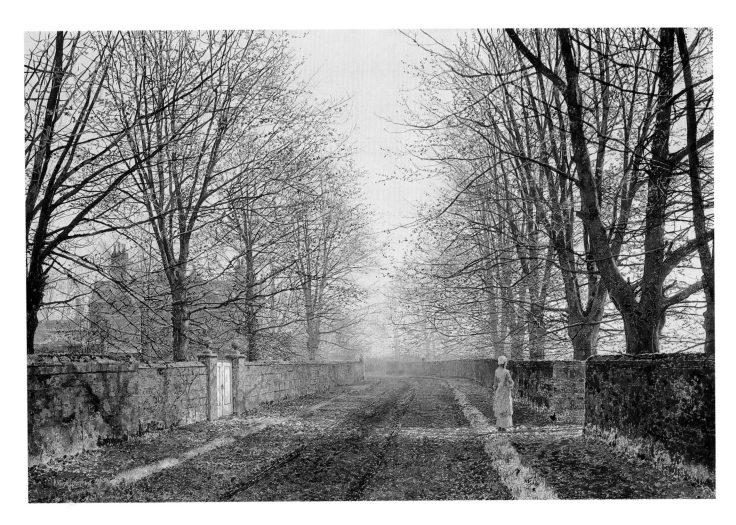

84. *Golden Light*. 1893. Oil on canvas, 45.7 × 68.6 cm (18 × 27 in). Collection of Mr Stanley Butterworth

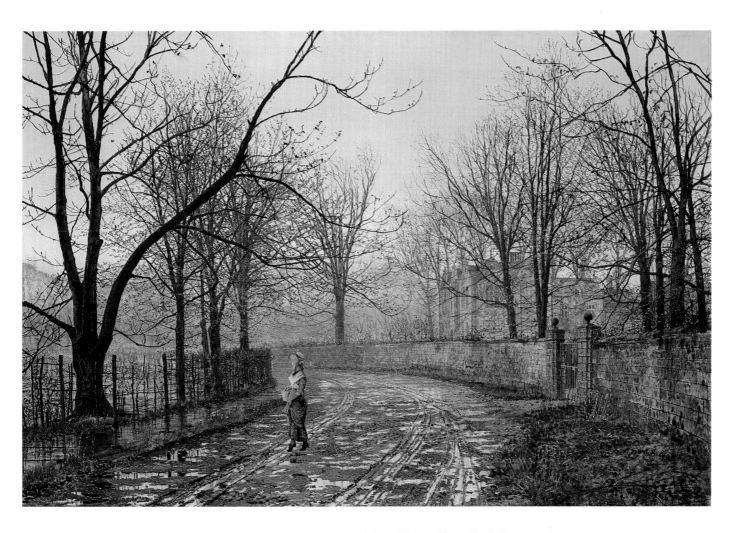

85. *Sixty Years Ago*. 1879. Oil on canvas, 81.3 × 122 cm (32 × 48 in). Private collection

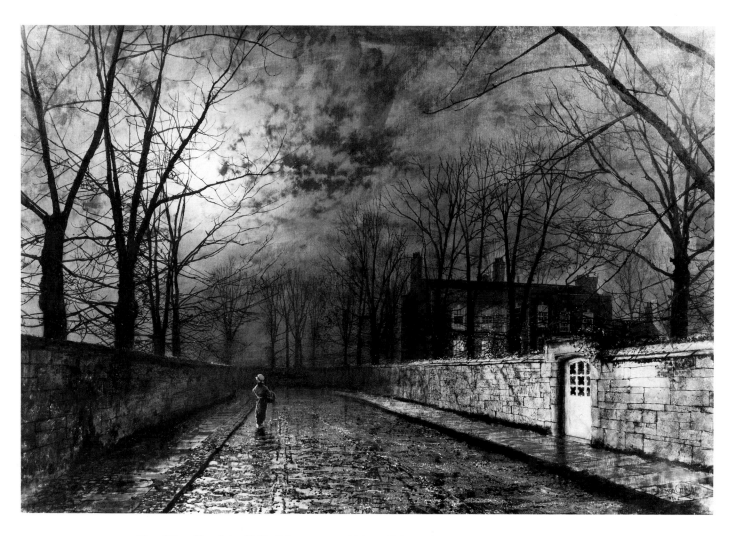

86. *Silver Moonlight*. 1886. Oil on canvas, 76.2 × 63.5 cm (30 × 25 in). Harrogate Museums
and Art Gallery

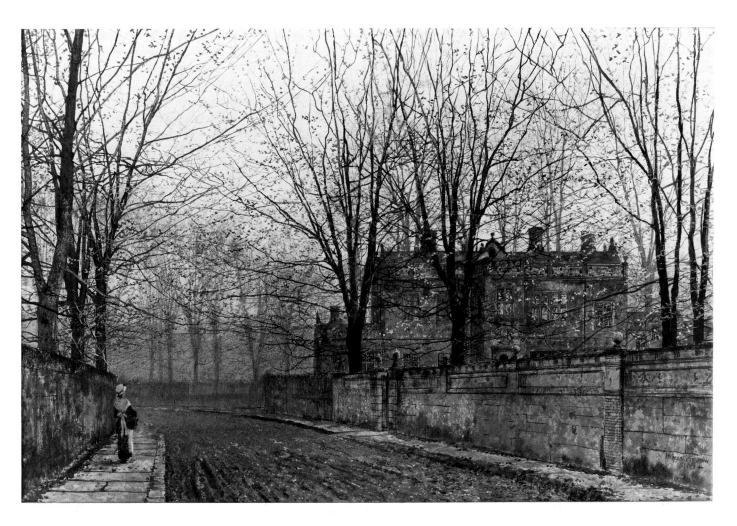

87. *November Morning*. 1883. Oil on canvas, 50.8 × 76.2 cm (20 × 30 in). Gateshead, Shipley
Art Gallery

88. *Sand, Sea and Sky: A Summer Fantasy*. 1892.
Oil on board, 30.5 × 45.7 cm (12 × 18 in).
Private collection

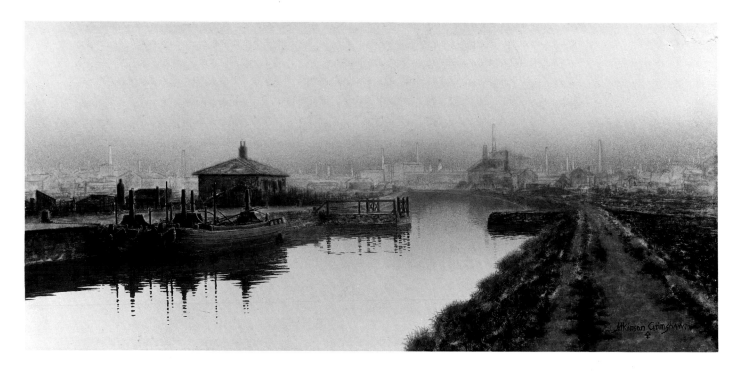

89. *Knostrop Cut*, Leeds. 1893. Oil on panel, 15.9 × 36.2 cm (6¼ × 14¼ in). Leeds City Art Galleries

autumn effects, with paintings bearing such titles as *Golden Twilight*, *The Glowing Gold of Autumn*, *Silver Moonlight* (Pl. 86), *November Morning* (Pl. 87), and *Golden Light* (Pl. 84). In the latter Grimshaw has 'warmed' the autumn tints; the composition is familiar but the effects are richer. Painted in the last year of the artist's life, the picture shows that he retained all his old powers from thirty years before, conjuring up, as always, the smell of damp leaves in the air, and the bright but chill light of autumn.

We know little of Grimshaw's commercial dealings. Throughout the 1880s he was well represented by the London art firms of Thomas Agnew and Arthur Tooth. He exhibited on three occasions at the Royal Academy and once at the Grosvenor. He maintained his London studio from 1885 to 1887, but then returned permanently to Knostrop Old Hall. Among those who bought his paintings in Leeds, we have the names of some of the leading businessmen and local families as lenders to exhibitions: Edward Simpson, Thomas Bolland, Henry Inchbold, members of the Harding family, and in particular Walter Battle, a Leeds Town Councillor and later proprietor of the *Leeds Times*. There is some speculation that Battle may have offered to help Grimshaw at the time of his financial crisis, and thereby acquired the large number of pictures he did. In Manchester, Grimshaw's paintings were bought by the well-known collector E. C. Potter who built up a very fine collection of contemporary art. In Scarborough, Thomas Jarvis bought Grimshaw paintings in numbers second only to Walter Battle.

In 1888 the Leeds City Art Gallery opened. Long talked of, especially by Edmund Bates in his pamphlet of 1862, the Gallery was to mount annual spring exhibitions in which Grimshaw was always represented. Although rather a shadowy figure, Grimshaw would occasionally write to the press—when, for instance, his identity was confused with that of a local beekeeper, or when he was thought to have died! He kept up his local standing by lending some of his collection of armour and ceramics to the conversazione of the Leeds Fine Art Club in 1890, and the same year lectured to the Leeds Photographic Society.

During the last two years of the decade Grimshaw's output diminished until, by 1890 and 1891, there are virtually no dated paintings at all. But this apparent decline was reversed when he suddenly ventured into an entirely new kind of subject: a series of small-scale paintings unlike anything he had produced before. *Knostrop Cut, Leeds* (Pl. 89) was painted not far from Grimshaw's home, along the nearby river. The colour range here is bright with greens, yellows and violet, used in a most sensitive way to suggest the colours of evening. *At Anchor* (Pl. 77) is one of a group of river-estuary paintings in which Grimshaw uses extreme simplicity of means—a harmony of two shades of blue joined by a smudgy black line, to suggest the river bank. The ship with its twinkling lights and inky black rigging becomes the focal point in this highly sophisticated river nocturne.

In the summer of 1892 Grimshaw produced two beach scenes which show a return to an interest in daylight effects. *Sand, Sea and Sky: A Summer Fantasy* (Pl. 88) contains suggestions of Boudin and, perhaps more immediately, of Whistler whose own beach studies were painted in the mid-1880s. Grimshaw's figures here have much more animation than was frequently the case before. It is possible that his son Louis provided assistance for them, but as Louis himself, in his own career as an artist, never produced anything remotely similar, it must be assumed that they are Grimshaw's. The other beach scene, *The Turn of the Tide* (Pl. 90), is devoid of human interest but shows a poetic fusion of observation and artistry, a return to Grimshaw's early years of direct communication with Nature. The beach is probably that of Scarborough, the town which Grimshaw loved to paint. In a passage from *Agnes Grey* by Anne Brontë, the heroine describes her delight in the Scarborough shore:

> When my foot was on the sands and my face towards the broad, bright bay, no language can describe the effect of the deep, clear azure of the sky and ocean, the bright morning sunshine on the semi-circular barrier of craggy cliffs surmounted by green swelling hills, and on the smooth, wide sands, and the low rocks out at sea—looking, with their clothing of weeds and moss, like little grass-grown islands—and above all, on the brilliant, sparkling waves. And then the unspeakable purity and freshness of the air!

Grimshaw too has echoed those feelings.

During the winter of 1892–3 the artist painted several snow scenes containing a lonely female figure and a few birds, seen against an empty white expanse. These were exhibited in the spring in Leeds to local acclaim, and for the rest of the summer Grimshaw continued to paint lanes, dock scenes and estuary pictures, even though he probably knew he was dying of cancer. He died on 31 October 1893 at Knostrop Old Hall. Unfortunately, in spite of Grimshaw's continuing high output in his last years, the contents of the house and studio had to be sold shortly after his death in order to raise money for the family, and few family records have survived.

Four years later a memorial exhibition of four local artists was held at the Leeds City Art Gallery, with paintings by Robert Atkinson, Edward March, Atkinson Grimshaw and Thomas Sutcliffe. Eighty-one Grimshaws were on show, including twenty-eight lent by his old friend Walter Battle. Thereafter Grimshaw's reputation all but disappeared, until the modern re-evaluation of the 1950s. Since then, several exhibitions, and the reappearance on the art market of major paintings from his early and middle period, have presented the opportunity to pursue a new study of the artist.

90. *The Turn of the Tide*. 1892. Oil on board, 24.7 × 49.5 cm (9¾ × 19½ in). Private collection

91. *Study of Beeches*. 1872. Oil on card, 42.5 × 54.6 cm (16¾ × 21½ in). Private collection

'NO MARKS OF HANDLING'

Grimshaw's Methods and Technique

By the death of Mr Atkinson Grimshaw, of Knostrop Old Hall, yesterday morning, a Leeds artist of very great ability has passed away. He may be regarded as self-taught in all that gave character and distinction to his art. His methods, treatment, and colouring were quite unlike anything in ordinary practice. Originality stamped his work from the first, and some of the effects which, early in his career, were successfully attempted, excited considerable controversy among contemporary artists. They showed no marks of handling or brushwork, and not a few artists were doubtful whether they could be accepted as paintings at all.

Obituary notice

The criticism that Grimshaw's paintings showed 'no marks of handling or brushwork', hints at a working method apparently mysterious, even suspect. However, this was certainly not the case. Grimshaw normally used a lead-white ground or a buff-tinted one. He usually underpainted in black and raw umber where the shadows or dense areas were to be. On to this surface he scumbled his broken colour, which allowed the light, so important in his work, to come back through; this helps to explain the large number of bristle hairs frequently found in this layer of the paint surface. He would then 'draw in', with black or whatever, the surface local colour, occasionally incorporating sand or sawdust in the impasto. Sadly to say, many Grimshaw paintings have been overcleaned, because restorers have not understood his low toning. Sometimes he would use a ready-primed canvas, normally preferring one with a smooth weave. He also frequently liked to paint on board or thick card. In all cases his effects were carefully worked out beforehand, a practice similar to Whistler's but using a quite different technique.

During the 1860s a series of watercolours was produced which were quite unlike his oil paintings. They are not many in number, but have a quality and importance which has been overlooked. Like most of the oils of this period, they are bright in tone and predominantly Pre-Raphaelite in delicacy of touch and observation. It is quite possible that Grimshaw was using watercolour as a means of experimentation during this period. A comparison of *The Vale of Newlands, Cumberland* (Pl. 92) with the oil painting *The Seal of the Covenant* (Pl. 93), shows an interaction of different techniques. The watercolour seems close to a photograph, particularly in the pebbles around and under the water in the foreground. The oil painting, on the other hand, is much more a piece of natural observation—not least in the tumbling, churned-up water of the mountain stream—yet, in the treatment of the hillsides, Grimshaw relies on the watercolour technique of 'floating on' patches of colour, separate from the general surface. A similar effect can be seen in *Nab Scar* (Pls. 94, 95). It is quite likely that as more examples from this period are discovered, further clues to Grimshaw's working methods will emerge.

92. *The Vale of Newlands, Cumberland.* 1868. Watercolour heightened with white, 35.2 × 51.1 cm (13⅞ × 20⅛ in). Private collection

93. *The Seal of the Covenant.* 1868. Oil on canvas, 71.1 × 91.5 cm (28 × 36 in). Leeds City Art Galleries

94. Detail of *Nab Scar* (Plate 95)

95. *Nab Scar.* 1864. Oil on board, 40.6 × 50.8 cm (16 × 20 in). Private collection

By the late 1860s Grimshaw's use of the watercolour medium was undergoing change. *Burnsall Valley, Wharfedale* (see Pl. 18) and its companion, *A Summer Noon, Old Farmstead, Upper Wharfedale,* are reminiscent of Birket Foster's over-elaborate style but Grimshaw avoids fussiness, and presents a successful painting of an actual place containing a real sense of atmosphere. In *Burnsall Valley* the leaves and twigs and Grimshaw's favourite wild flower, the foxglove, create something of a foreground surface pattern which throws the rest of the composition into recess. The treatment of branches and foliage, the stippling effect of the middle distance, are both techniques taken over into the oil paintings of the next two decades. The two main trees, however, have similarities to photographs taken by John H. Morgan in the 1850s, when individual studies of natural objects were so popular. Yet, in spite of Grimshaw's ability to paint with such jewel-like technique, he was, after about 1868, to abandon watercolour altogether.

No artist from the 1850s onwards was unaware of the uses to which he could put photography. Some used it openly, some furtively. Many photographers tried to make their prints resemble paintings, using similar poses and groups to ape the success of the easel painter. Ruskin's advocacy of the daguerreotype as an aid to study or drawing was obviously exceeded by many who could see the advantage of using a virtually instantaneous image. As early as 1847 Ford Madox Brown was writing that he was thinking of having some daguerreotypes struck off in order to save time with his figures. Holman Hunt could well have used some of James Graham's photographs of the Holy Land in 1854. D. G. Rossetti and Millais both had recourse to photographs, and it is well known that Frith utilized some views taken at Epsom for his *Derby Day.*

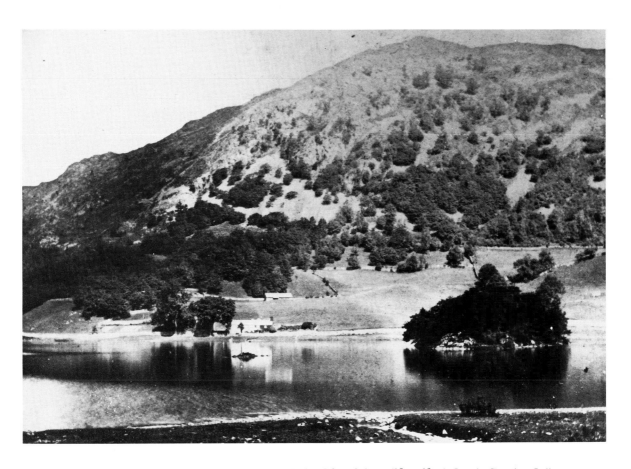

96. Thomas Ogle. Photograph of Nab Scar. *c.*1864. 5.9 × 8.6 cm (2⅜ × 3⅜ in). Leeds City Art Galleries

Atkinson Grimshaw's use of photography spans his whole career. Two prints were used directly as the source of paintings done in 1864 and 1865—*Blea Tarn at First Light, Langdale Pikes in the Distance* (see Pl. 7) and *Nab Scar.* A photograph taken by Thomas Ogle of Penrith (and now in Grimshaw's photograph album at Leeds City Art Gallery) provided the artist with most of the detail for the latter composition (Pl. 96). There are subtle variations introduced by the artist, not only in the entire foreground, which does not appear in the photograph, but also in the spreading ripples on the lake, the reflections of the banks in the water and various other changes to the stone walls and tree clumps. Grimshaw has painted over a white ground—a particular feature of early Pre-Raphaelite paintings—and uses brilliant, unnaturalistic colours, probably based on Pre-Raphaelite works which he could have seen. The picture of *Blea Tarn,* based on a photograph by Garnett, has another 'Grimshaw' foreground, plus the introduction of a heron, a favourite device of the artist and later used in similar compositions with titles such as *Sun Dip* and *The Heron's Haunt.* Grimshaw also 'invented' a pebbly beach and a complete lily pond, no doubt intending to make what is already a romantic spot into one even more poetic. Both these early paintings have a rather airless quality but, nevertheless, are convincing attempts at producing a Pre-Raphaelite landscape. Perhaps the artist has here followed the prints more than nature, but as *aides-mémoire* the photographs served their purpose well.

The existence of one sketch from the 1860s, however, shows clearly that Grimshaw did on occasion look directly at nature. The simply titled *Mr Flowers Sketch* (Pl. 97) is the basis for the finished oil painting *November Morning on the River Wharfe* (Pl. 98). The painting itself is dated 1866, by which time Grimshaw's use of

97. *Mr Flowers Sketch.* *c.*1866. Pencil, 12.2 × 18.2 cm (4¾ × 7⅜ in). Leeds City Art Galleries

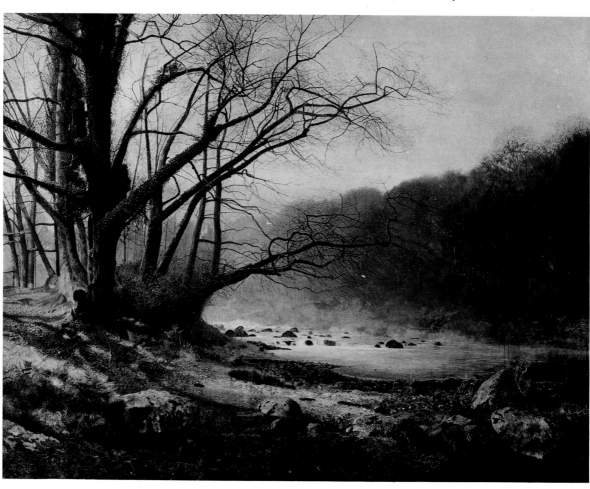

98. *November Morning on the River Wharfe.* 1866. Oil on canvas, 69.8 × 90.2 cm (27½ × 35½ in).
Private collection

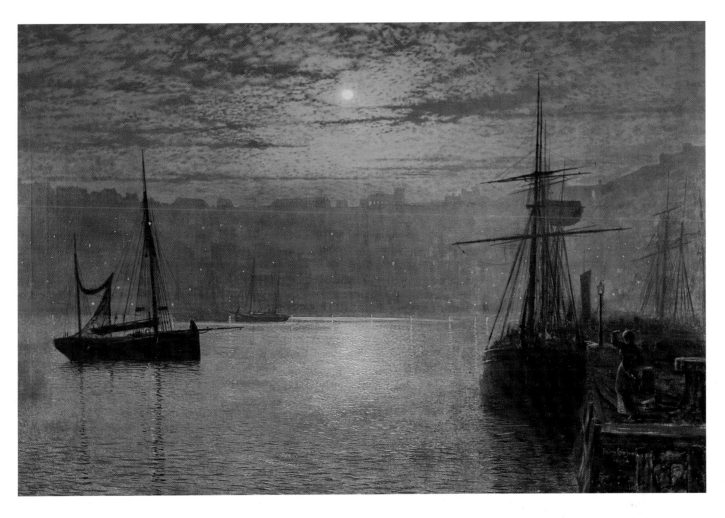

99. *Lights in the Harbour*. 1879. Oil on canvas, 82.5 × 121.9 cm (32½ × 48 in). Scarborough Art Gallery

commercially available photographs may have ceased. For, although Lakeland scenes produced around 1863–5 must be presumed to be based on photographic prints (now lost), the artist's use of such reference material does not seem to have outlasted this series of views, except possibly in one instance—*Autumn Glory: The Old Mill, Cheshire*, 1869 (see Pls. 22, 24), where the mill building itself is perhaps related to a photographic source. Grimshaw has in fact reversed the mill, probably for artistic reasons, in order to achieve a better balance between the archway and windows. For the crisp detail of the woodland with its ivy and bramble, he had his own early studies to fall back on.

Other examples of Grimshaw's work hint, at least, at an interest in photography. *Study of Beeches* (Pl. 91), showing some magnificent old trees situated in the grounds of Gledhow Hall, Leeds, could quite easily be based on photographs of the type favoured by John H. Morgan—early photographers tended to choose trees with bare branches, in order to avoid a blurred image that might be caused by moving foliage. Whatever his source, Grimshaw obviously chose a stark subject for its poetic effect.

Paintings by Grimshaw which show a blaze of light from the sky down to the water may well have owed part of their inspiration to the photographs of Gustave Le Grey, whose successful prints showing correctly exposed sea and sky, complete with billowing clouds, had been hailed as landmarks in the 1850s. *Scarborough Bay* (see Pls. 50, 52) contains this dazzling effect, as does *Lights in the Harbour* (Pl. 99), where moonlight and artificial light vie for the spectator's attention. But here, in order to paint the backdrop to the scene, Grimshaw used one of his own pencil sketches of the Scarborough skyline above the South Bay (Pl. 100). He took the same sketch again for *Nightfall in the Harbour, Scarborough* (Pl. 101), showing, as it does, the gateway tower of the castle at the right, and in the centre, St Mary's Church, burial place of Anne Brontë. *The Lighthouse at Scarborough* (Pls. 102, 109) shows Grimshaw using his technique in ways which extend his usual practice. By his choosing to view the harbour from across the wet sand, the whole surface is made to gleam with light, reflected from the hazy moon.

From the mid-1870s Grimshaw had manipulated his painting technique to subsume detail into the background, where it appears to merge with the gloom. This use of schematic outline is very apparent in *Whitby Harbour* (Pl. 106), and gives his painting a naïve appearance, so that the boats, houses, and hillside have an almost 1920s, St Ives School, look. At the same period he continued to produce canvases in his usual style, applying his varied skills to show the full range of his abilities. It is in such paintings as *Whitby from Scotch Head* (Pl. 103) that a connection with the famous Whitby photographer, Frank Meadow Sutcliffe, appears strongest. However, there is no recorded acquaintance, and, if anything, Sutcliffe's photographs appear to imitate Grimshaw; whatever similarities there are probably come from both men being interested in the same subjects.

A point of particular interest about these coastal views is the strong indication they give that by the 1870s, whilst Grimshaw was certainly using photographic material to achieve certain specialized effects, he was by no means wholly dependent on photographs as the basis of his paintings. Indeed, several instances have now been mentioned where Grimshaw used related studies for pictures. Although surviving examples are few, he may have produced many more detailed sketches similar to that for *Barnes Terrace* (Pl. 104), which contains exact colour notes for the series of oil paintings of this subject (Pl. 105). While in Scarborough Grimshaw used his sketchbook, particularly around the old town, gathering information on which he could later draw.

100. *Scarborough Skyline. c.*1877. Pencil, 12.2 × 18.2 cm (4¾ × 7⅜ in). Leeds City Art Galleries

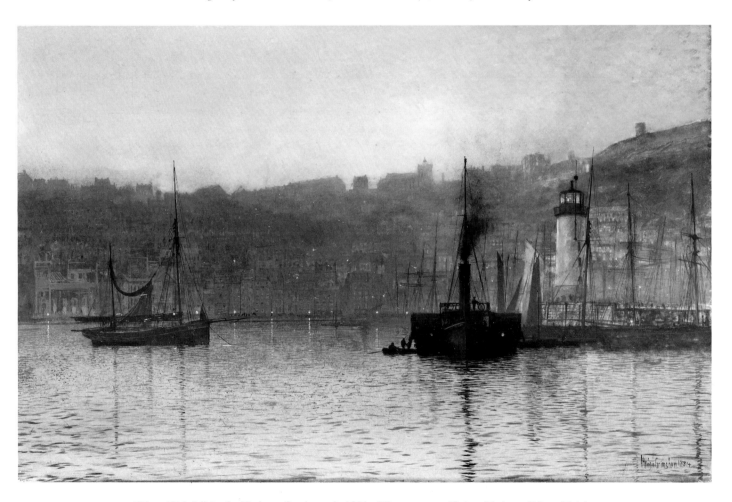

101. *Nightfall in the Harbour, Scarborough.* 1881. Oil on canvas, 58.4 × 91.4 cm (23 × 36 in).
Leeds City Art Galleries

102. *The Lighthouse at Scarborough*. 1877. Oil on board, 22.9 × 35.6 cm (9 × 14 in). Private collection

In spite of Grimshaw's apparently decreasing use of photography after 1870, that he did occasionally paint over photographs completely in the 1880s is known from several examples: *Briggate, Leeds*; *St Ann's Square, Manchester*; and *Pall Mall, London*, where the prints have been stuck on to a stretched canvas. The paintwork is usually very tightly handled, and the pictures are completed with a delicate signature. Just why Grimshaw did this cannot be satisfactorily explained, and examples are very few in number.

Although there exist two or three photographs of his children at Knostrop, we do not know if Grimshaw used a camera himself. However, in the years 1890–3, towards the end of his life, he is listed, along with his son Louis, as a member of the Leeds Photographic Society. Another son, Wilfred, was a member in 1886 and 1888. This link with the Society probably brought about the invitation to give a lecture to its members on 2 October 1890—a talk which Grimshaw called *Watchwords for Workers*. It was briefly reported in the local press:

> After criticizing a number of lantern slides shown by members of the society, Mr Grimshaw insisted upon the necessity of a study of perspective by photographers, pointing out that they had the privilege of acquiring absolute truth of form by the God-sent art science of photography, and he advised them to use it wisely. Nature alone, however, possessed the full range of light and photographers must be content with an octave or two in the middle of the manual, and not attempt to grasp the full length of the key-board.

There is certainly a lingering hint of Ruskinian teaching here.

116

103. *Whitby from Scotch Head*. 1878. Oil on canvas, 20.3 × 43.2 cm (8 × 17 in). London,
Richard Green Gallery

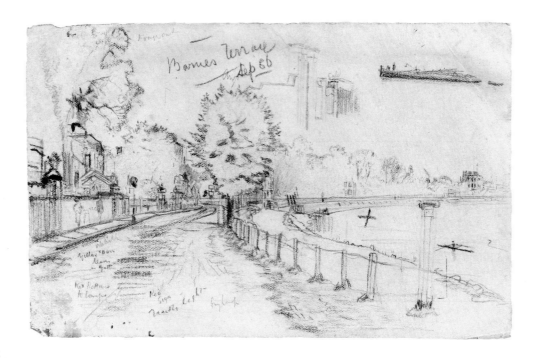

104. *Barnes Terrace*. 1886. Pencil, 11.4 × 18 cm (4½ × 7⅛ in). Leeds City Art Galleries

One story, long current in the Grimshaw family, concerns an 'open day' held at the artist's studio around 1890 when Grimshaw invited the press along to observe how he could project an image from a lantern slide on to a canvas and draw over the projected outlines. Such methods were reported in photographic journals as far back as the 1850s, but no first-hand reports of Grimshaw's using this technique have been located in the Leeds press, nor is it clear for how long the process might have been employed by him. If it was for some time, it would explain the large number of his suburban-lane paintings and dock scenes, which are often identical compositions in reverse.

When Atkinson Grimshaw died, the *Yorkshire Post* obituary mentioned some of the artist's friends, among them 'Mr Whistler'. This reference, together with the family tradition of a connection, is all we have to link him directly with Grimshaw. Yet their common love of the river Thames and of night effects generally would certainly have brought them together when Grimshaw took the Chelsea studio in the mid-1880s.

A copy of Whistler's *Gentle Art of Making Enemies*, annotated by Grimshaw, is now at Leeds City Art Gallery. Significantly, he has marked the famous passage from Whistler's *Ten O'Clock Lecture*:

> And when the evening mist clothes the riverside with poetry, as with a veil, and the poor buildings lose themselves in the dim sky, and the tall chimneys become campanili, and the warehouses are palaces in the night, and the whole city hangs in the heavens, and fairy-land is before us—then the wayfarer hastens home; the working man and the cultured one, the wise man and the one of pleasure, cease to understand, as they have ceased to see, and Nature, who, for once, has sung in tune, sings her exquisite song to the artist alone, her son and master—her son in that he loves her, her master in that he knows her.

105. *On the Thames, Barnes*. 1886. Oil on canvas, 61 × 91.5 cm (24 × 36 in). Private collection

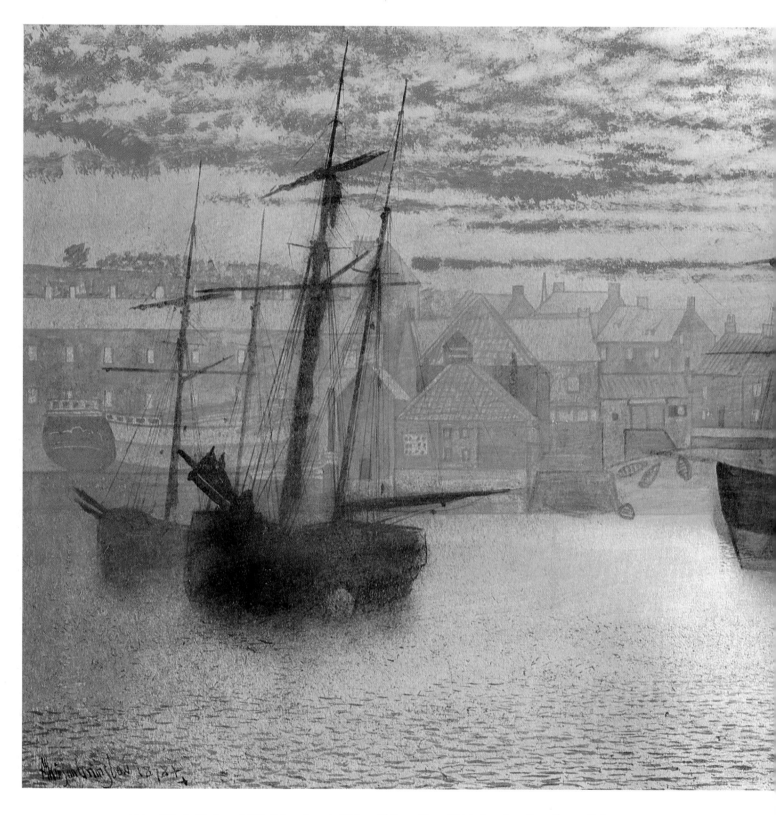

106. *Whitby Harbour*. 1878. Oil on board, 20.3 × 43.2 cm (8 × 17 in). London, Bury Street Gallery

Whistler's own painting methods were unique to him (Pl. 107), but Grimshaw was capable of evoking similar feelings about the river using his own very different means (Pl. 108).

Another passage marked by Grimshaw in the same lecture proclaims the important point, 'Nature contains the elements, in colour and form, of all pictures, as the keyboard contains the notes of all music.' If this sounds familiar, in fact it is very close to Grimshaw's own lecture to the Leeds Photographic Society at the beginning of October 1890. Yet he notes in the Whistler book that he did not read Whistler's lecture until 19 October of that year. If so, it shows how close Grimshaw had moved to Whistler's ideas by the end of his life. Certainly, in the late paintings, *At Anchor* (Pl. 77) and *Sand, Sea and Sky: A Summer Fantasy* (Pl. 88), a new Whistlerian sensibility is very evident pointing to a fresh development in Grimshaw's career—a development sadly cut short by his early death at the age of fifty-seven.

If Grimshaw's London fame was short lived, in the North his style was much imitated. Indeed, his success throughout the north of England made it worthwhile for outright forgers to copy his style. Most of their work is extremely superficial; even the two main Leeds copyists, Walter Meegan and Wilfred Jenkins, could only base

107. James McNeill Whistler. *Nocturne: Blue and Gold—Old Battersea Bridge.* 1872–3. Oil on canvas, 66.6 × 50.2 cm (26¼ × 19¾ in). London, the Tate Gallery

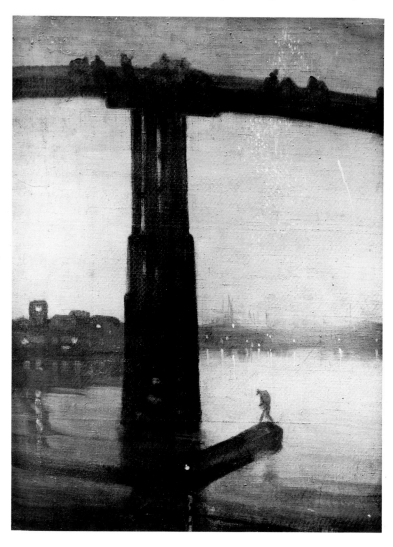

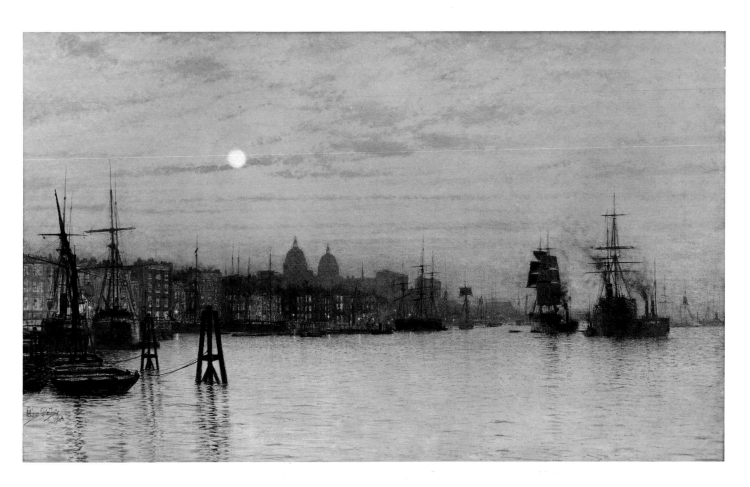

108. *Greenwich: Half-Tide*. 1884. Oil on canvas, 55.9 × 91.5 cm (22 × 36 in). Gateshead, Shipley Art Gallery

their versions on the bare essentials of a 'Grimshaw'. Harsh colouring and a total lack of sensitivity in all the details, if any, are the hallmarks of their efforts. Their suburban lanes pay minimum attention to textures, shadows or careful observation, with crude, white highlighting and a completely 'unnatural' moon added as the final touch.

Two of Grimshaw's sons, Arthur and Louis, painted, but Arthur was more interested in a career in music, and, rather than abandon his vocation, left home in order to compose, and at the same time take up the post of organist at St Anne's Cathedral, Leeds. Louis Grimshaw was the most successful of his father's followers, and assisted him towards the end of his life. He later copied some of Atkinson Grimshaw's compositions but gave them his own colour harmonies. However, even Louis's reputation as an artist did not long outlast the turn of the century.

In an obituary notice for Grimshaw, the reviewer ended a survey of his career with the following words:

> Daylight effects had little attraction for him; the details were too hard and staring; and it was the mystery of the murky air, the tender hues of the dawn, or the mellow light of the moon thrown on all beneath it, a silvery radiance, that appealed to him most deeply. Last year his art found another field for its exercises. The result was some remarkable wintry landscapes, charmingly delicate and original in treatment. It may be said without exaggeration that he has left no successor behind him.

BIBLIOGRAPHY

Publications on Grimshaw:

JANE ABDY, *Atkinson Grimshaw*, London, 1970
SANDRA K. PAYNE, *Atkinson Grimshaw. Knight's Errand*, Wokingham, 1987
GUY RAGLAND PHILLIPS, *John Atkinson Grimshaw 1836–1893*, Leeds, 1972

Exhibition catalogues:

LEEDS, 1897, *Robert Atkinson, Atkinson Grimshaw, Edward March, Thomas Sutcliffe*
LONDON, 1957, Arthur Jeffress Gallery, *Atkinson Grimshaw 1836–1893*
NEW YORK, 1961, Durlacher Brothers, and Rhode Island School of Design, *William Etty: Atkinson Grimshaw*
LONDON, 1964, Ferrers Gallery, *Grimshaw*
NEWCASTLE UPON TYNE, 1967, Stone Gallery, *Atkinson Grimshaw of Leeds*
YORKSHIRE AREA MUSEUM SERVICE TOUR, 1970, *Atkinson Grimshaw*
LONDON, 1976, Alexander Gallery, *Atkinson Grimshaw*
HARROGATE, 1976, Alexander Galleries, *Atkinson Grimshaw, his son Louis and followers including Wilfred Jenkins, Walter Meegan and Samuel Wagstaff*
LEEDS, 1979, City Art Gallery, *Atkinson Grimshaw*

Source studies for this book, and related reading:

JANE ABDY, 'Tissot: his London Friends and Visitors', in *James Tissot 1836–1902*, exhibition catalogue, Barbican Art Gallery, London, 1984
MICHAEL BARTRAM, *The Pre-Raphaelite Camera*, London, 1985
ASA BRIGGS, *Victorian Cities*, London, 1968
JENNI CALDER, *Women and Marriage in Victorian Fiction*, London, 1976
MARGARET DRABBLE, *A Writer's Britain: Landscape in Literature*, London, 1979
TREVOR FAWCETT, *The Rise of English Provincial Art*, Oxford, 1974.
DEREK FRASER (ed.), *A History of Modern Leeds*, Manchester, 1980
JEREMY MAAS, *Victorian Painters*, London, 1969
JOHN RUSKIN, *Modern Painters*, third edition, 1846–60
AARON SCHARF, *Art and Photography*, London, 1968
ALLEN STALEY, *The Pre-Raphaelite Landscape*, Oxford, 1973
RAYMOND WILLIAMS, *The Country and the City*, London, 1973
CHRISTOPHER WOOD, *Tissot*, London, 1986

The obituary notice quoted on pp. 107 and 123 is taken from an unidentified press cutting in the Leeds City Reference Library.

PHOTOGRAPHIC ACKNOWLEDGEMENTS

The publishers wish to thank all museums, galleries and others who have contributed towards the reproductions in this book. Further acknowledgement is made to the following: *5*: Calderdale Museums Service; *7, 102,* © Christie's; *13:* reproduced by permission of Her Grace the Duchess of Devonshire; *15, 64, 77, 89*: Richard Green Gallery; *78*: Paul Mellon Collection; *1, 6, 10, 14, 16, 26, 36, 38, 80, 105*: Sotheby's; *34, 110*: Sotheby's Inc.; *33, 87, 108*: Tyne and Wear Museums Service.

PAINTINGS IN PUBLIC COLLECTIONS

Despite the vast quantity of paintings and drawings that Atkinson Grimshaw produced, only a few of his works are in public museums and galleries. The majority remain in private collections and are rarely seen, and this has contributed to the relative obscurity of the artist. Listed below are all the public collections which hold one or more examples of his work.

AUSTRALIA
Victoria, Shepperton Arts Centre
ENGLAND
Bournemouth, Russell-Cotes Art Gallery and Museum
Bradford, Cartwright Hall
Gateshead, Shipley Art Gallery
Gloucester, City Museum and Art Gallery
Halifax, Bankfield Museum
Harrogate, Art Gallery
Huddersfield, Art Gallery
Hull, Ferens Art Gallery
Leeds, City Art Gallery
Liverpool, University Collection
Liverpool, Walker Art Gallery
London, Guildhall Art Gallery, Corporation of London
London, Tate Gallery
Newcastle, Laing Art Gallery
Preston, Harris Museum and Art Gallery
Scarborough, Crescent Art Gallery
Staffordshire, Eccleshall Castle
Wakefield, Art Gallery
Whitby, Pannett Art Gallery
FRANCE
Brest, Musée des Beaux-Arts
South Africa
Port Elizabeth, King George VI Art Gallery
USA
Hartford, Wadsworth Atheneum
Kansas City, Nelson Gallery
Minneapolis, Institute of Arts
New Haven, Yale Center for British Art
New Orleans, Museum of Art
Rhode Island, Museum of Art, Rhode Island School of Design

109. *The Lighthouse at Scarborough* (Plate 102)

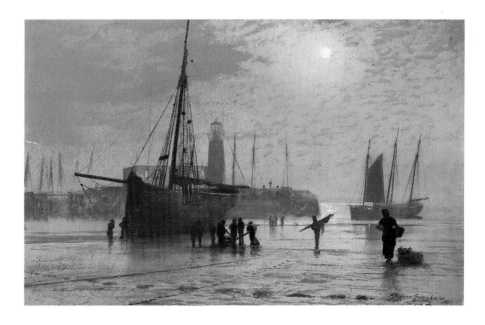

INDEX

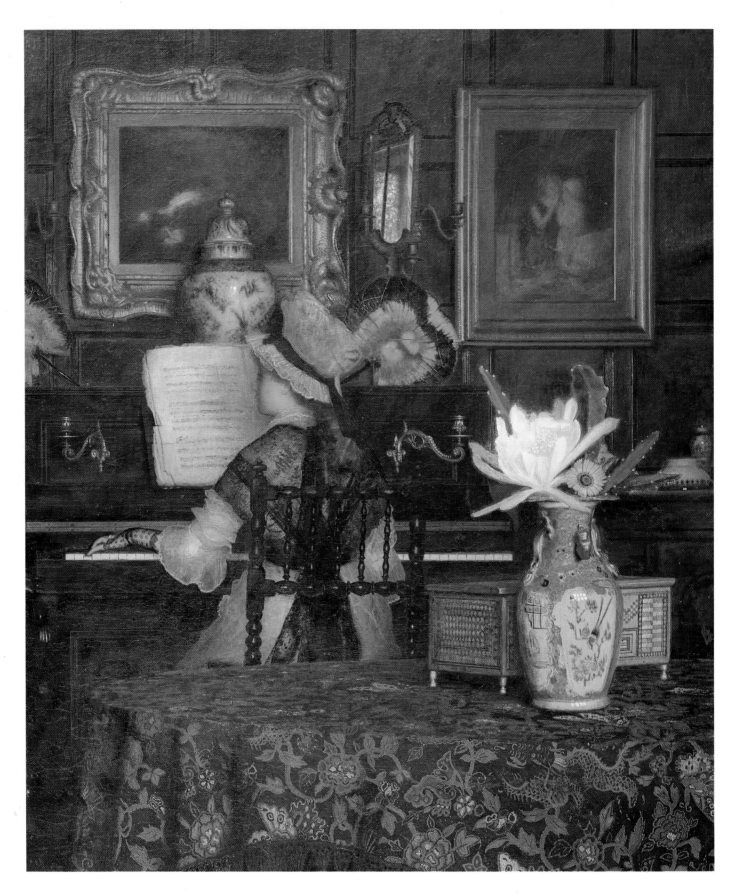

110. Detail of *Dulce Domum* (Plate 34)